DUNDEE PUBS

BRIAN KING

AMBERLEY

To everybody who has been to the pub with me.

First published 2021

Amberley Publishing
The Hill, Stroud
Gloucestershire, GL5 4EP

www.amberley-books.com

Copyright © Brian King, 2021
Maps contain Ordnance Survey data.
Crown Copyright and database right, 2020

The right of Brian King to be identified as
the Author of this work has been asserted in
accordance with the Copyrights, Designs and
Patents Act 1988.

ISBN 978 1 4456 9698 0 (print)
ISBN 978 1 4456 9699 7 (ebook)

British Library Cataloguing in Publication Data.
A catalogue record for this book is available from
the British Library.

Origination by Amberley Publishing.
Printed in the UK.

Contents

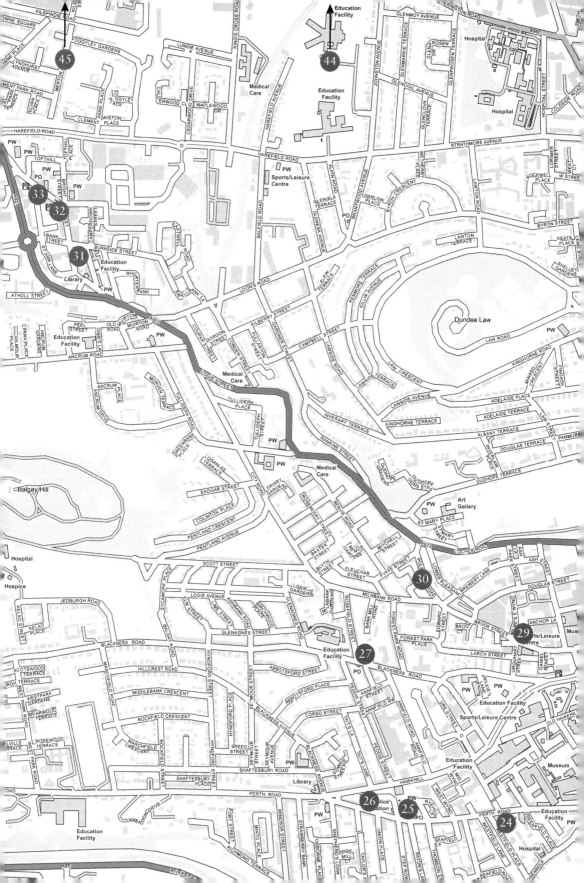

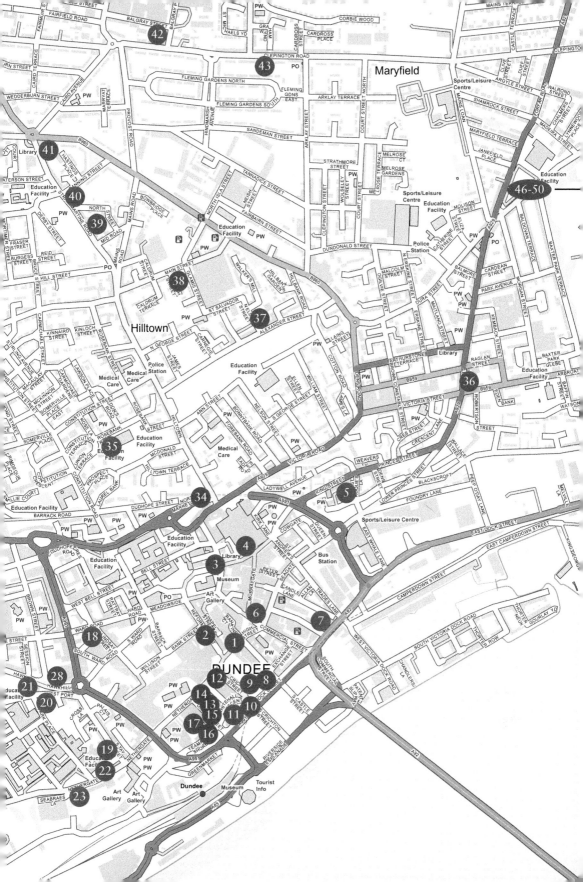

Key

1. The Arctic Bar, New Inn Entry
2. The Old Bank Bar, Reform Street
3. BrewDog, Panmure Street
4. Caw's Bar, Panmure Street
5. The John O'Groats, Cowgate
6. Tickety Boo's, Commercial Street
7. Number 57, Dock Street
8. The Wine Press, Shore Terrace
9. The St Andrews Brewing Company – Caird Hall, Shore Terrace
10. The Bird and Bear, Whitehall Crescent
11. Abandon Ship, Whitehall Crescent
12. The Pillars, Crichton Street
13. Draffens, Couttie's Wynd
14. The Trades House, Nethergate
15. Dynamo Dundee, Union Street
16. The Club Bar, Union Street
17. The King of Islington, Union Street
18. Clarks on Lindsay Street
19. The Beer Kitchen, South Tay Street
20. Tom's Pacific Cocktail Parlour, Temple Lane
21. Molly Malone's, West Port
22. The Phoenix, Nethergate
23. No. 172 at the Caird and Capone's, Nethergate
24. The George Orwell, Perth Road
25. The Taybridge Bar, Perth Road
26. The Speedwell Bar (Mennie's), Perth Road
27. The Balgay Hill Bar, Rosefield Street
28. Duke's Corner, Brown Street
29. Beiderbecke's Bistro and Cocktail Bar (formerly the Royal Oak), Brook Street
30. Bissell's Bar, Polepark Road
31. Kelly's Bar, High Street, Lochee
32. The Last Tram, High Street, Lochee
33. The Albert Bar, High Street, Lochee
34. The Ladywell Tavern, Victoria Road
35. The St. Andrews Tavern, Rose Street (demolished)
36. Harlequins, Albert Street
37. The Ellenbank Bar, Alexander Street
38. The Snug, Church Street
39. The Barrels
40. The Athletic Bar, Strathmartine Road
41. Frew's, Strathmartine Road
42. The Ambassador, Clepington Road
43. The Clep, Clepington Road
44. The Downfield (Doc Stewart's), Strathmartine Road
45. The Nine Maidens, Laird Street
46. The Gunners, King Street
47. The Eagle Coaching Inn, King Street
48. Fisherman's Tavern, Fort Street
49. The Ship Inn, Fisher Street
50. The Royal Arch, Brook Street

Introduction

This is not a pub guide in the traditional sense. It will not tell you where to buy the finest whiskies or who serves the best meals. It will not tell you which pubs have the best entertainment or which are good for a quiet evening. Indeed, just because a pub is featured does not mean that it is recommended at all, and similarly, if you are staring at this book with incredulity because your favourite Dundee hostelry does not appear, then be assured that it has only been missed out due to reasons of space or because it does not fit the format, not because of any deficiency as a venue. Instead, this book is a look into the history of the city's pubs, the landlords, stories, notable architectural features and the more unusual bars. For the most part, it features pubs that the reader can go and visit today. Only on a couple of occasions are establishments from the past featured at length, though many others will be mentioned along the way.

What we would now recognise as a pub has had a long evolution, deriving from the taverns, inns and ale houses that were to be found in Scottish burghs such as Dundee since the Middle Ages. As early as 1558, the town's council sought to regulate drinking, imposing a curfew that prevented 'drinking in any ale house or wine tavern efter ten hours of the nicht'. For centuries, ale was commonly drunk because it was safer to drink than water. This had an unfortunate consequence in 1651, according to local folklore, when the local population were said to be suffering the after-effects of ale consumption allowing the town to be easily taken by General Monck for Cromwell.

Against this background, it is not surprising to learn that Dundee has a long tradition of brewing. The brewers' organisation the Maltmen Fraternity dates from at least the sixteenth century and is one of the Nine Incorporated Trades of Dundee. Brewing survived in the city until the closure of Park and Pleasance Breweries in 1960. More recent years have seen the trade return to the city, albeit on a smaller scale than before.

By 1853, when what constituted a pub became more defined and regulated by the Forbes Mackenzie Act, there was said to be one pub for every 144 inhabitants in Dundee. Like many industrialised towns, nineteenth- and early twentieth-century Dundee had a problem with excessive alcohol consumption. As well as the recognised drinking establishments there were

numerous illegal shebeens. Local poet William McGonagall tackled the subject in his own distinctive style:

> Oh, thou demon Drink, thou fell destroyer;
> Thou curse of society, and its great annoyer.
> What hast thou done to society, let me think?
> I answer thou hast caused the most of ills, thou demon Drink.

Winston Churchill, the city's former Member of Parliament, famously referred to the 'bestial drunkenness of Dundee', though his view may have been coloured by the fact that he had been defeated in an election by Edwin 'Neddy' Scrymgeour, the only person ever to be elected to Parliament as a prohibitionist.

Thankfully, the country did not go down the road advocated by Scrymgeour and some actively sought to make drinking a more comfortable and respectable business with the opening of so-called palace pubs such as the Speedwell or the Whitehall (now the Bird and Bear). Nevertheless, many of Dundee's pubs remained very basic until the 1960s. By the late 1970s, though, some had been modernised. Laminated tabletops and plastic chairs replaced simple wooden tables and benches and modern fittings replaced traditional pub lighting and mirrors. As if to underline that the traditional pub was a thing of the past the fittings from some Dundee pubs went on to form a feature in the local museum.

A decade or two later, however, and the traditional pub was back in fashion to the extent that it was decided to put the pub display back into storage following the refurbishment of the McManus Galleries. Pubs in Dundee today, though, are not all merely recreations of a time gone by and there are establishments to cater for every taste, including, as we shall see, many distinctive and unusual bars.

I

City Centre

Monday nicht's the Dundee Arms
Tuesday nicht's the Pump,
Wednesday nicht's the Arctic Bar
Where maybe we'll get drunk

Only the Arctic Bar survives of the city centre pubs mentioned in this old verse. The Dundee Arms was in the High Street opposite the top of Whitehall Street while the Pump was in the Overgate. Redevelopment of the Overgate area saw the replacement of several historic streets with a shopping centre. The late 1950s and early 1960s saw the loss of many old pubs in this area including the Swan, the Variety Bar, JB Lawson's, the A1 Bar, the Lindsay Tavern, the Harp and Thistle and The New Bank Bar.

As well as demolitions, the post-war period also saw the dispersal of much of the population from the city centre to modern housing schemes on the edge of town, which eventually gained pubs of their own. Luckily, several historic pubs have survived and still grace Dundee's city centre. Some have maintained their traditional appearance while others have adopted a more modern look. Others still have appeared in buildings that were not originally pubs either effectively recreating the traditional look or opting for something more distinctive.

1. The Arctic Bar, New Inn Entry

It would be easy for a visitor to Dundee to miss the Arctic Bar, despite it being one of the city's oldest and most centrally located pubs. This is because it is hidden from the High Street in a lane known as New Inn Entry. Before the construction of Reform Street in the 1840s, this was the main route from Dundee's High Street to the town's meadows (the present-day site of Albert Square and remembered in the street name Meadowside).

In the late eighteenth century, the New Inn itself, from which the Entry takes its name, was built facing the High Street by merchant William Wilson. As early as 1790, the Arctic Bar's predecessor was advertising 'a good stock of liquors of all kinds'. The inn's facilities included six large parlours, some twenty bedrooms, an elegant ballroom and a large kitchen. To the rear were stables for sixty horses and space for eight carriages.

By 1823, part of the premises to the rear of the New Inn were in use as Dundee's post office. In 1837, though, the post office moved to the top of Castle Street and the site at New Inn Entry was

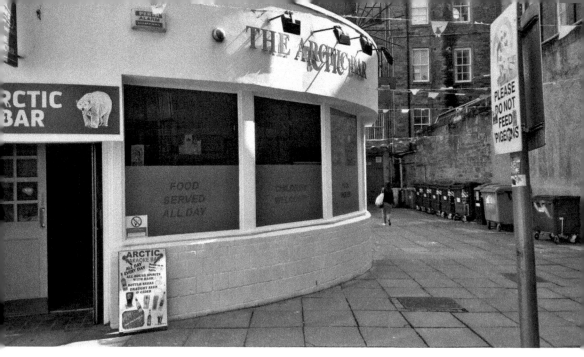

Above: The Arctic Bar, New Inn entry.

Below: The older side of the Arctic Bar.

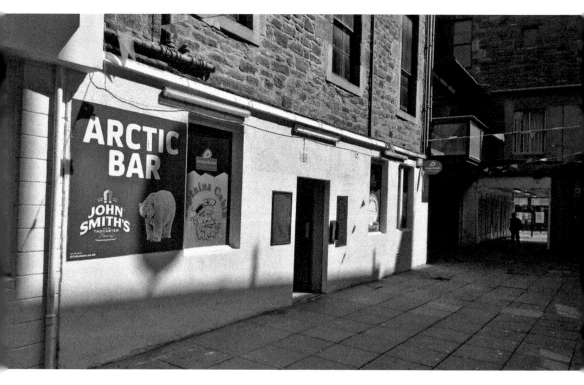

a 'Draught Ale and Porter Establishment' soon after, and certainly by 1845. The Arctic Bar has been adapted and extended over the years and, viewed from certain angles, it might be thought to be a relatively modern pub. A closer look at the exterior, not to mention the survival of interior features such as an old disused staircase and an original cobbled floor in the basement, show that this is a much older establishment.

There has been a persistent story that the Arctic Bar got its name as this was where Dundee's whalers were paid. The name undoubtedly invokes the Dundee whaling fleet's voyages to the Arctic region and payment of workers in a pub was not unknown. It is easy to see why pub landlords might be keen to participate in such a scheme. It may be, though, that they were paid in an office before retiring to the nearest pub. In the nineteenth century, New Inn Entry was home to several lawyers' and other offices and wages may have been collected from one of these. The Entry also contained the premises of a diminutive blacksmith named Justice – giving rise to the local riddle: Why is New Inn Entry like the Court of Session? Because it contains plenty of law and little Justice!

2. The Old Bank Bar, Reform Street

The Old Bank Bar in Reform Street was originally a branch of the Bank of Scotland. It seems reasonable to suppose that the adjacent street, Bank Street, took its name from this. The former bank opened as a pub in 1984. This was not, however, Dundee's first Old Bank Bar. The old, Old Bank Bar was situated at Nos 25–27 Murraygate with its lounge – known as the Clan Lounge – being entered from the adjacent pend. It was a popular city centre pub until its closure in 1968.

Nor is the present Old Bank Bar to be mistaken for the Bank Bar, which is in Union Street and was once a branch of the TSB and still retains the bank's original safe. In 2019, licensees Paul

The Old Bank Bar, Reform Street.

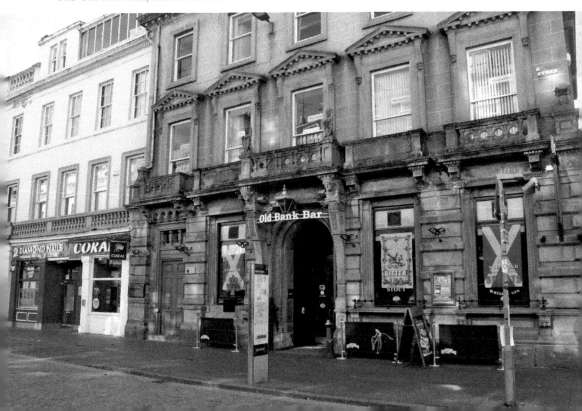

and Susan Russell celebrated twenty years in charge – a great achievement in times of changing fashions, drinking habits and regular pub closures.

There might have been a temptation when it opened, to call the Bank Bar the New Bank Bar, but this might have caused confusion among an older generation who remember that there was a New Bank Bar in the Overgate (i.e. the old Overgate that preceded both versions of the shopping centre). The licensee of the New Bank Bar in the 1920s was George Telfer. Telfer was previously in charge at the Old Bank Bar in the Murraygate, so it seems likely that he chose the name. It closed in 1959. There was also an Old Bank Bar in Lochee, which was the predecessor of what was latterly known as the Sporting Lounge.

Back in present-day Dundee, there are several pubs that were previously banks including the Trades House (formerly a Royal Bank of Scotland), Nicoll's Bar (a former Commercial Bank of Scotland branch) and, as the name suggests, The Counting House (previously the Clydesdale Bank). Indeed, anyone who had been away from Dundee for decades could still easily locate a decent pub simply by remembering where there used to be a bank. Meanwhile, in the Murraygate, the premises that once housed the original Old Bank Bar… is now a bank.

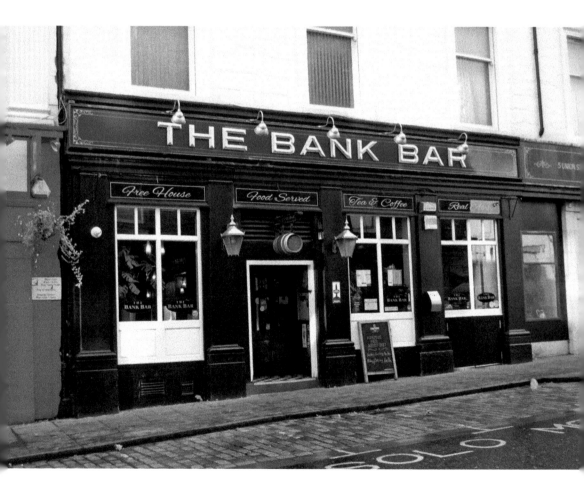

The Bank Bar in Union Street.

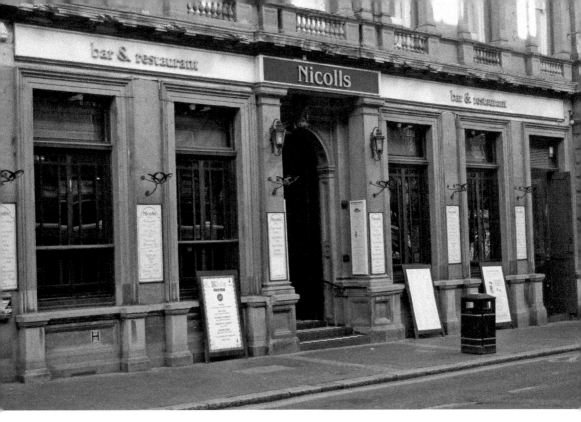

Above: Nicolls in Commercial Street is also a former bank.

Below: The Counting House.

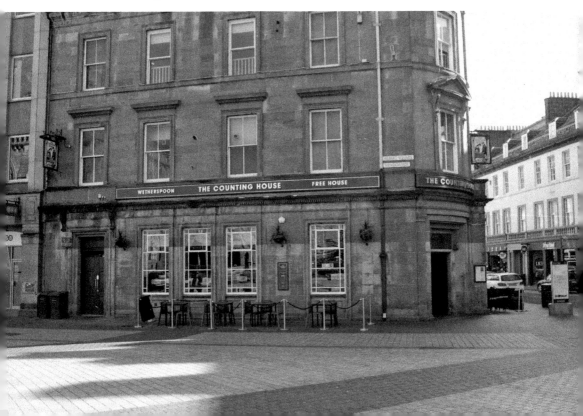

3. BrewDog, Panmure Street

BrewDog was founded by James Watt and Martin Dickie, who began brewing beer in Fraserburgh in 2007. Starting on a small-scale basis, they initially filled the bottles by hand and sold their beers at local markets. Their range of craft beers quickly became popular and the business expanded rapidly. In 2010 they moved into the pub business, opening a bar in Aberdeen – the first of more than eighty now operating around the world. In 2014, BrewDog's Dundee premises was opened. While this might be a relatively new Dundee pub, it occupies the ground floor of a truly historic building – the former Royal Exchange Building at Panmure Street, formerly the home of the Dundee Chamber of Commerce.

From its formation in 1836, Dundee's Chamber of Commerce met in the Baltic Coffee House, a meeting place situated at Bain Square between the Wellgate and the Cowgate, which was rented from the Dundee Union Bank. By 1850, it was decided to move to purpose-built accommodation on the edge of the town's meadows. Despite the picturesque name 'the meadows' (now the site of Albert Square) consisted of around an acre and a half of boggy ground caused by the confluence of several water sources.

A competition was held to design the building, which Edinburgh architect David Bryce won with his design in the style of a fifteenth-century Flemish-Gothic Cloth Hall. As was the case with such buildings there were many ornate details, including intricate decorative stone work on the dormer windows and large gargoyles projecting out from the square tower at the east end. In the original plans, this tower had been intended to have a two-tier decorative extension capped by a crown spire. As work progressed, however, it became clear that the boggy ground could not support the weight involved and that the building would begin to sink. Plans for the

BrewDog in the former Royal Exchange Building.

crown spire were consequently abandoned. A tower that featured on the original plans for the Albert Institute (now the McManus Galleries) later suffered a similar fate. The difficult building conditions also meant that work on the Royal Exchange took longer than expected and the building was finally opened with an inaugural festival on 1 April 1856. One hundred and fifty years later the then Dundee and Tayside Chamber of Commerce was forced to close after getting into financial difficulties and the building was turned over to other uses.

4. Caw's Bar, Panmure Street

Caw's Bar has been a feature of Dundee's Panmure Street for just over 150 years. The street itself was officially opened in 1839 and named after William Ramsay Maule, 1st Baron Panmure, in recognition of his then recent donations to the funds for the infirmary. It was not until around thirty years after this, though, that Caw's opened for business at No. 25 Panmure Street. Even then, it did not begin life as a pub. In its early days, and indeed for much of the twentieth century, it was known as Caw's Restaurant.

The licensed restaurant was initially run by a partnership composed of two brothers – William and James Caw. Early advertisements for the restaurant boasted of William Caw's 'famous Welsh pies'. Caw's quickly established a reputation as a venue for special gatherings and played host to celebratory suppers for clubs, sporting organisations and workplaces. One such gathering took place in 1877 when the last of the workers employed in the iron moulding department at the new Tay Bridge had a supper at Caw's Restaurant to celebrate the completion of their work on the structure. The joyful evening ended with the singing of 'Auld Lang Syne'. The revellers could not know that, two years later, the bridge of which they were so proud would collapse, leading to the deaths of all passengers and crew on a train that was crossing at the time.

Caw's restaurant in the nineteenth century.

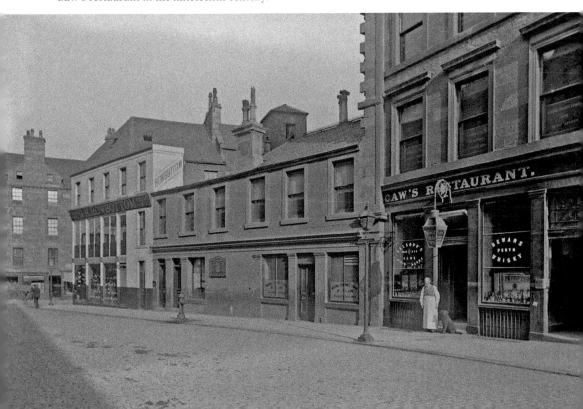

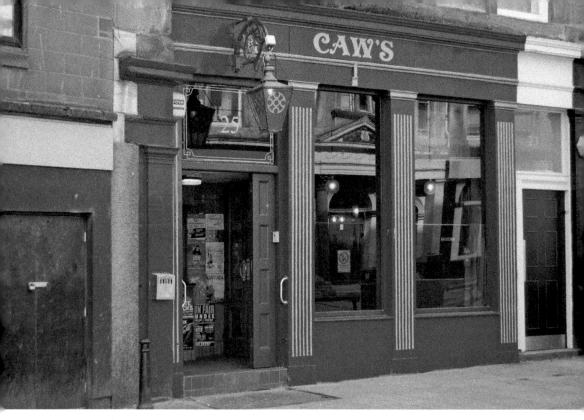

Caw's Bar today.

The Caw brothers amicably ended their partnership in 1874 and William continued to run the business in partnership with another brother, Charles. After this, Charles carried on alone before eventually passing over to his son William. The restaurant's future in the Caw family seemed secure but tragedy hit in 1904 when William died at the age of thirty-five. Nevertheless, his widow Euphemia took over the licence – later followed by her grandson William Findlay. It remained with a company he formed – Caws Restaurant Limited – until the 1960s.

Caws has been a pub rather than a restaurant for decades and consequently the interior bears little resemblance to how it would have looked in the early days. The name has been retained, though, and the shopfront with its trademark hanging lamp would still be recognisable to a visitor from the 1860s, though they would no doubt notice that the door has been moved from the centre to the left-hand side.

5. The John O'Groats, Cowgate

The building that once contained the John O'Groats still stands at the corner of the Cowgate and St Roque's Lane, but it has not been a pub for more than fifty years. It is still remembered in Dundee, though, partly because of its unusual location. While the pub occupied the ground floor of the building, the upstairs was home to the Wishart Memorial Church, which at one time was attended by the famous missionary Mary Slessor. This unusual juxtaposition caused the building to be nicknamed Heaven and Hell.

A plaque on the outside of the building dates it to 1841. The existence of an old staircase that once connected the upper and lower floors indicates that perhaps the whole structure was intended to be given over to one purpose, but soon after it was built the unusual combination of church and pub was in place.

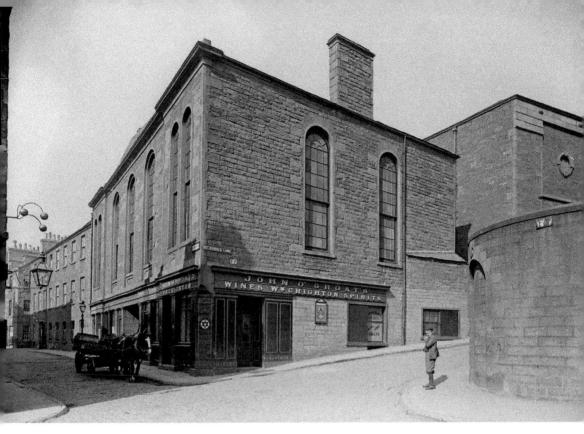

Heaven or Hell? The John O'Groats.

One of the oldest pubs in Dundee in its day, the John O'Groats cements its place in the city's popular culture by making an appearance in the song 'The Bureau', which dates from the time of the Great Depression of the 1930s and was sung to the tune of 'Bye Bye, Blackbird'. It tells the story of unemployed men from various parts of Dundee. ('We're the lads fae the tap o' the Hill/never worked never will ... We're the lads fae Norries Pend/never worked, don't intend'.) In an effort to avoid being dependant on the Bureau of Employment (or the 'broo' as it was more commonly known in Dundee), the would-be workers secure a number of jobs, none of which seem to last long:

> We got a job wi' Willie Lang the bookie,
> Collecting lines at the corner o' St Rookie
> We gied oot too much sub,
> Spent the rest in the John O'Groats pub,
> Bookie bye, bye

Some versions of the song name other pubs, but if the hapless bookies runners were really 'at the corner o' St Rookie' (St Roques Lane) then the John O'Groats would certainly have been the nearest hostelry.

From 1921 until it closed its doors for the final time in 1967, the John O'Groats was run by Peter Smith. Over those years the surrounding area had gradually depopulated as slums were cleared and people moved out to new housing schemes. The pub did not survive Smith's retirement and, as if to emphasise its passing into history, many of the bar fittings were transferred to the Dundee Museum at that time.

6. Tickety Boo's, Commercial Street

In 1879, James Grant Speed was successful in securing a public house licence for a new shop at the corner of Seagate and Commercial Street. The large premises had its own kitchen and had been considered suitable for use as a restaurant. Speed kept a large selection of wines and spirits and was also a wholesaler and importer. In 1884, he was given permission to extend the premises with the introduction of an upper room.

When his father William died in 1898, James Speed moved back to run his family's licensed premises at Perth Road and he would later open the Speedwell Bar there. In the years following his departure from the Empire Bar, as it was then known, there were several landlords but none lasted very long. His immediate successor, William Wilson, went bankrupt within eighteen months.

In 1914, the pub became one of the earliest in Dundee to be taken over by a sportsman when footballer Herbert Dainty took over the licence. Dainty, who was born in Geddington, Northamptonshire, in 1879, had played six seasons for Dundee FC and had been part of the famous team that won the Scottish Cup in 1910. After serving as player/manager of Ayr United (their first ever manager), Dainty undertook a similar role at Dundee Hibernian (who later became Dundee United). He was later manager, club secretary and, briefly, chairman of Dundee Hibs.

In 1922, the Empire was sold and became the Bogeda when the Bogeda Company Limited transferred its business there from the Murraygate. It remained in their ownership for more than thirty years. There was a brief hiccup in 1947, however, when the Bogeda lost its licence for

Tickety Boo's.

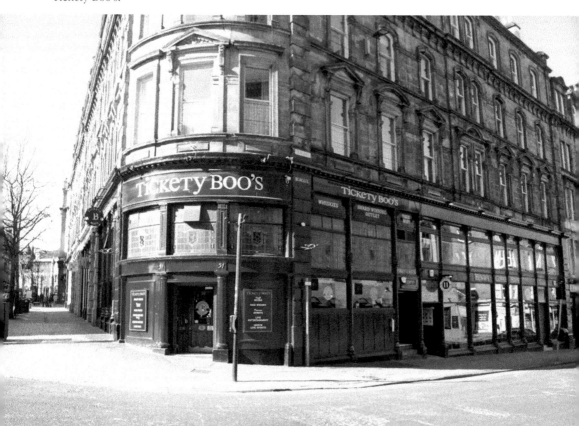

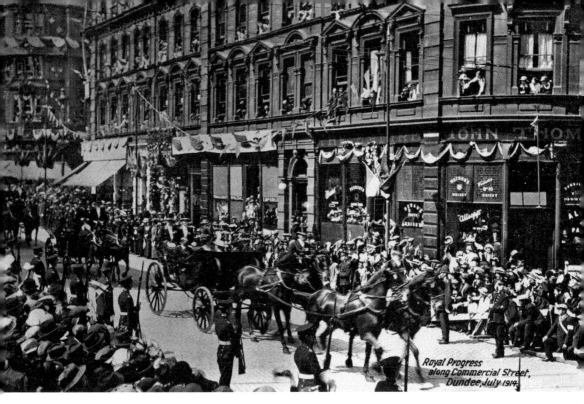

King George V passing the Empire Bar in 1914.

selling watered-down whisky, though it was restored the following year. The Bogeda Company renovated the pub, making it into one large room and much as it appears today.

In 1955, the pub came into the ownership of John Jeffrey & Co. Ltd and was later renamed Jeffrey's Bar. Many will also remember it as the Hansom Cab or the Coach House, before the change to the present name – Tickety Boo's. The interior fittings may have been updated over the years, but the exterior, with its leaded stained-glass windows, remains much as it would have done more than a century ago. Like all stained glass, however, the rose and thistle motifs are best viewed from the inside and a trip upstairs handily brings them to eye level.

7. Number 57, Dock Street

As we shall see, the Club Bar in Union Street was once the Great Western Bar, which raises the question: was there ever a Great Eastern Bar? The answer is that there was and it was located at No. 57 East Dock Street, which today is known by the self-explanatory name of Number 57 and is a popular live music venue. It opened as The Great Eastern Wine and Spirit Store in the late 1860s. At that time the Great Eastern was part of a two-storey building, which it shared with a painter's shop and workshop. In June 1880, however, this was completely destroyed by a devastating fire.

The building was replaced with the distinctive Arts and Crafts-style structure that remains today consisting of three storeys and an attic and designed by architect John Murray Robertson. This structure, which is now B-listed, included a new Great Eastern Bar. The shopfront remains much as it was in 1880, though the pub at that time was entered by doors on either side of the present entrance. The high level stained-glass windows are original.

In its early days, the Great Eastern would have been at the heart of the thriving dock area. Almost a century later the Earl Grey and King William IV Docks were filled in to make way for

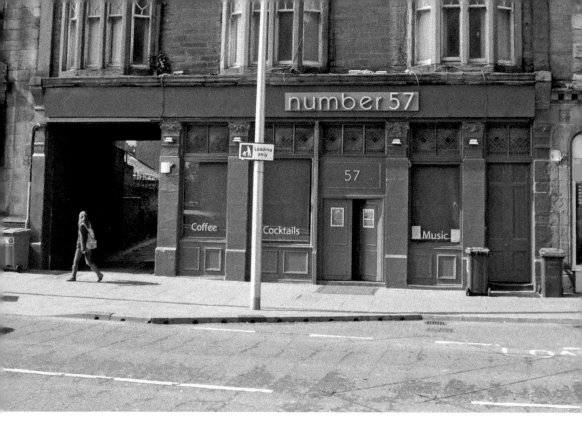

Above: Number 57 in Dock Street.

Below: The Great Eastern.

the landfall of the Tay Road Bridge. While this removed the immediate hazard of customers from the pubs in the area falling into the water, it also removed the traditional source of that custom.

The Great Eastern name survived well into the twentieth century. The pub was later called The Gateway and then the Unicorn Lounge – presumably in honour of the HMS *Unicorn*, the historic frigate that is berthed nearby. Today, as Number 57, it is a rare survivor of the many old pubs that once populated the Dock Street area.

8. The Wine Press, Shore Terrace

The Cesarewitch Handicap is a horse race that is run each October at Newmarket. Inaugurated in 1839, its name is an anglicised version of tsarevich, the title of the heir to the Russian throne. In 1895, ten minutes before the start of that year's race, two horse-drawn cabs full of plain clothes police officers drew up at the Dundee pub The London House (today known as The Wine Press). They went to each of the pub's two entrances and entered the premises. Backed up by a number of other officers, they had come to raid the pub on suspicion that illegal gambling was being organised there. Among those arrested and led out in front of the hundreds who had gathered on the street that day was the landlord Tam Hogan, who subsequently lost his licence. The premises were turned over to other uses, including some time as a potato merchant's. It would not be until 1912 that they were reopened as a public house, causing an interruption in a history that went back until at least the 1860s.

The larger building, which contains the Wine Press, has an even longer history. It was built as the Exchange Coffee House in 1830 and was intended as a facility for Dundee's merchants, which would include a meeting place, library and reading rooms. It was hoped the ground floor

The Wine Press in the former Exchange Coffee House.

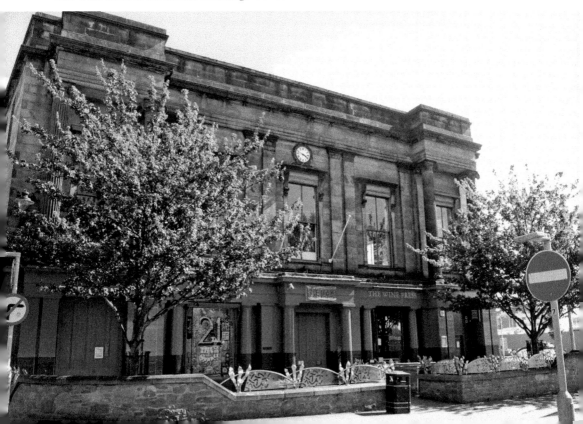

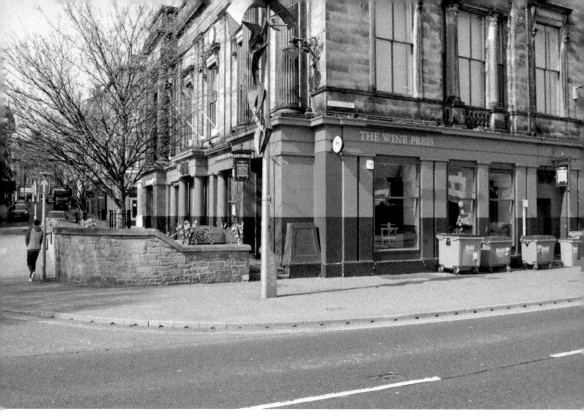

The Wine Press from Dock Street.

would be home to a new Custom House, but it was instead given over to shops and offices. The present Wine Press premises was occupied as a grocer and spirit dealer in the 1850s and later as a public house.

Over the years the pub has had several names. It was called The London House from at least 1868, when it was refurbished by new landlord John Brimner, until the early twentieth century. It has also been the City Centre Bar, The Drum, The Chelsea Lounge and, most controversially of all, Lennon's – after the late former Beatle John Lennon. The pub traded under this name for several years before receiving a cease and desist letter from the legal team of Lennon's widow Yoko Ono in 2011. It was quickly renamed Legends, and Lennon's likeness and related memorabilia were removed.

In 2015, the pub became The Wine Press operated by Aitken Wines, a long-established Dundee firm that had been founded as far back as 1874 when James Aitken first opened premises on the Perth Road.

9. The St Andrews Brewing Company – Caird Hall, Shore Terrace

Before the construction of the Caird Hall and the City Square, the area between the High Street and Shore Terrace was occupied by a network of streets and lanes including the Vault, St Clement's Lane, Tindal's Wynd and Castle Lane. There was also an open space at the foot of Crichton Street, known as the Greenmarket. This whole area was home to several public houses, and at the corner of the Greenmarket and Shore Terrace there stood a hotel known as the Crown Hotel. On 24 May 1909, a meeting was held at the Crown Hotel to set up a new football club and appoint its first office bearers. The club in question was Dundee Hibernian, who later became Dundee United. A plaque at Shore Terrace commemorates this event.

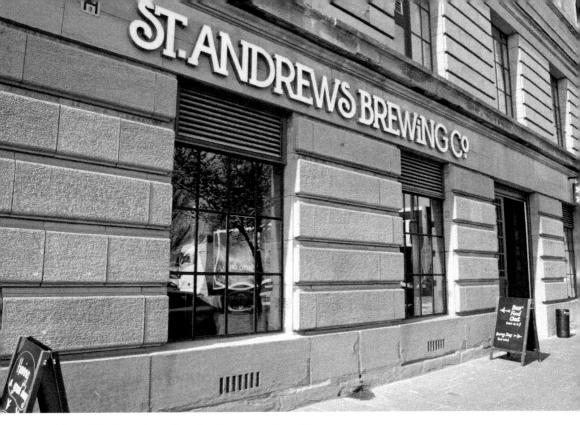

Above: The St Andrews Brewing Company, Shore Terrace.

Below: The Crown Hotel where Dundee United FC was founded.

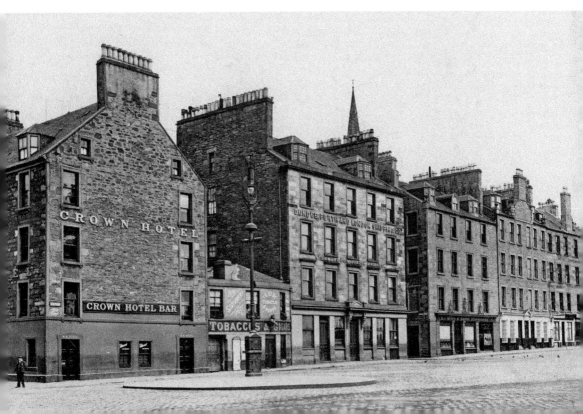

When the Caird Hall was built, the space underneath at Shore Terrace was given over to the City Arcade and Market, which was officially opened on 27 November 1923. The arcade, which contained a wide range of retailers and amusements, remained popular for the next half century and is still fondly remembered today. Its popularity began to decline, though, when the city turned its back on its waterfront area with the construction of the Tay Road Bridge. It was dealt a fatal blow when the Corporation bus stance was removed from Shore Terrace and Tayside House constructed. The arcade finally closed its doors in 1981. The premises were later used for council offices.

The waterfront redevelopment saw the demolition of Tayside House and the removal of the council offices to Dundee House as well as the opening of Slessor Gardens, making the former city arcade premises attractive to new businesses. In 2018, the St Andrews Brewing Co. took over two units there to open a bar restaurant. Founded in 2012, the St Andrews Brewing Co., as the name suggests, is based in St Andrews in Fife, where they opened the town's first brewery in more than a century. Their beers quickly grew in popularity and are now sold throughout the county. The company later expanded into the pub business, opening two premises in St Andrews.

The Dundee Caird Hall site was the company's most ambitious project yet. Comprising some 7,500 square feet, the units, which had been stripped back to basics, had to be completely fitted out from scratch. The space available meant that there was room for a seventy-seat restaurant area.

10. The Bird and Bear, Whitehall Crescent

With its striking modern interior, a visitor from outwith Dundee entering the Bird and Bear might suspect that this was perhaps a relatively recent conversion of an older building, but it has, in fact, been a pub since 1898. It was not called the Bird and Bear at that time, however,

John Powrie and staff outside the Whitehall.

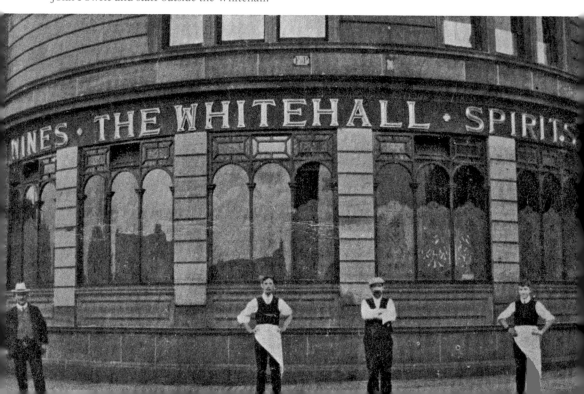

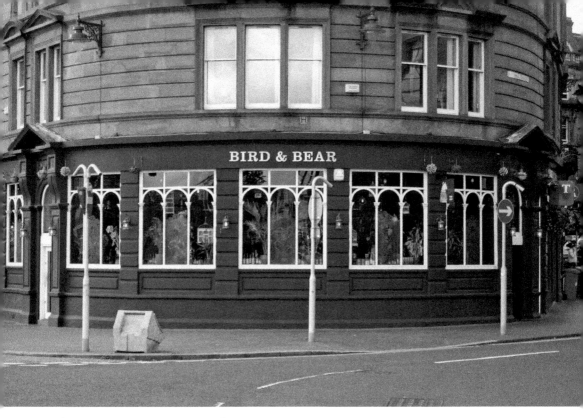

The Whitehall is now the Bird and Bear.

but rather the Whitehall Bar. The name came from the then newly opened Whitehall Crescent, in which the pub is situated. It, in turn, was so named because the adjoining street, Whitehall Street, was supposed to have been the site of a royal residence of the same name, though this has long been dismissed by historians.

The first proprietor of the Whitehall Bar was John Powrie. Powrie's father and latterly his mother had been the licensees of a public house at No. 15 Dock Street for decades prior to this. The sorry state of these premises was recounted by Powrie Sr's solicitor, William Johnston, in 1889 when he was attempting to transfer his licence elsewhere. Johnston said that the entrance was bad there was no sanitary accommodation whatsoever and, moreover, there was no cellarage. It must have been astonishing then for John Powrie when he walked into the brand new Whitehall Bar, which was built on the site of his parents' old pub. It is easy to understand why such late Victorian public houses were known as 'palace pubs'. Sadly, in 1907, Powrie lost the pub after getting into financial difficulties.

The pub continued to be called the Whitehall Bar until well into the twentieth century before adopting a variety of names – some more appropriate for a nineteenth-century public house than others – including The Galleon, Sliks, Flares, The Kitchen, Sheridan's, The Waterfront and The Tasting Rooms.

11. Abandon Ship, Whitehall Crescent

While the Bird & Bear has been a pub under one name or another for more than a hundred years. The premises next door at No. 2a Whitehall Crescent (formerly No. 14 Dock Street) were, until the 1960s, occupied by James Cowan & Sons, salt merchants. Before moving to the new

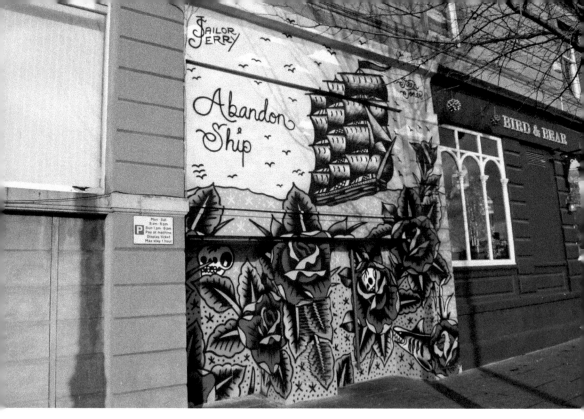

Abandon Ship's striking mural.

building in 1900, they had shared the same building with the Powries' old pub and the two remained neighbours for much of the twentieth century.

By the 1970s, however, the former warehouse and cellar had been adopted by the pub next door. In more recent years it has been a separate bar. Previously the Jam Jar, No. 2a is now Abandon Ship, an 'American dive bar'-themed pub.

Even the exterior of Abandon Ship lets the visitor know that this is something different. A striking mural by artist Steen Jones covers the entire front of the premises and contrasts sharply with the more minimal exterior décor of the Bird and Bear. Jones was specially commissioned to come to Dundee from Australia to create the artwork.

Once inside, you pass through an entrance area featuring arcade games, before emerging into the main bar area. There is more than 70 square metres of artwork completed by Richard Davies, the founder of the Abandon Ship clothing brand, which was launched in 2011 and from which the Abandon Ship bar emerged. The bar also contains memorabilia from the brand's history and a large 'Not Everything Sucks' logo above the bar as well as a custom bar top. There is also a mezzanine level, which acts as a dining area.

12. The Pillars, Crichton Street

Crichton Street takes its name from a Dr Crichton whose house stood in the way of the proposed new road. Crichton sold the house to the council on the condition that the street was named after him. The shop at No. 9 was used for various purposes over the years. Alcohol was sold there as early as 1849 when grocer John Archbold added wines and spirits to his stock. By 1855 it was

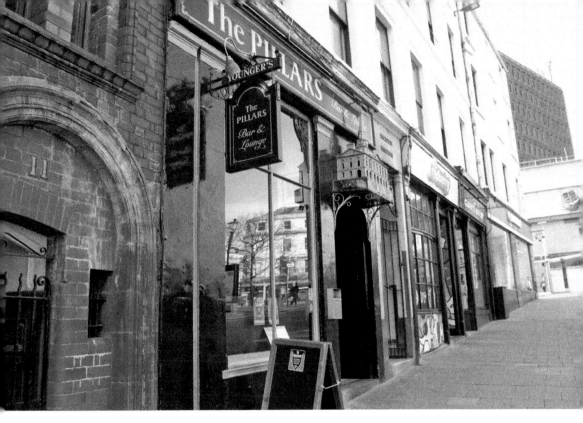

Above: The Pillars.

Below: Inside The Pillars.

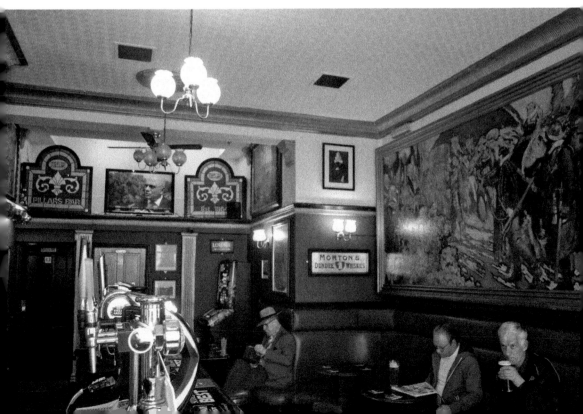

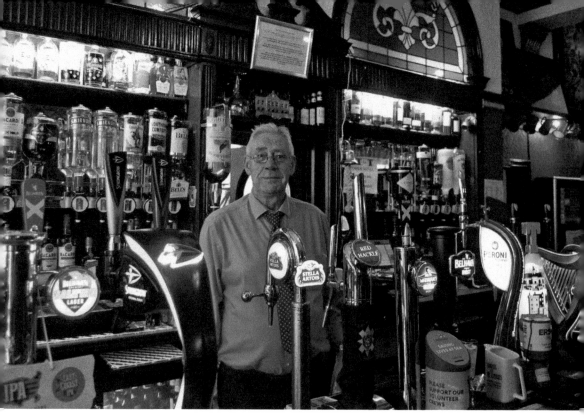

Behind the bar of The Pillars.

being operated by Thomas Skene as a working men's coffee house and reading rooms. In 1864, Skene obtained an alcohol licence, establishing the premises as a public house.

It is difficult to imagine that pub being called anything other than The Pillars, but in the late nineteenth and early twentieth centuries it was known as The Lyceum. The Pillars name commemorates Dundee's Town House, which was built in 1732 and stood where the City Square is today. This building was known locally as 'the pillars' because of its colonnade, which was a popular meeting place. It was demolished in 1932 and the same year a commemorative copper model was installed above the door of the pub at No. 9 Crichton Street. The model contained 1,105 pieces of copper and 1,754 rivets, and used 8 ounces of silver solder. It contained a working clock and lit up at night. When the new City Chambers were being built nearby concerns were raised as to the number of projecting signs on Crichton Street, leading to them all being taken down with the exception of the one at The Pillars, which was recognised as being something exceptional.

In 1947 the pub's licence was extended to cover the shop premises at No. 15 Crichton Street (now the Salty Dog). This shop had also been used for many different purposes, including a rope and twine merchants, a clothes shop and a confectioner's. Previously known as the Pillars Lounge, it originally was used to serve three-course lunches. The Salty Dog is connected to The Pillars by a passage and staircase, which runs behind the building at Nos 11–13 Crichton Street. Viewed from the front, though, they are separated by this building. Add to this the fact that each has its own entrance and bar and it is easy to imagine a visitor to the city attempting a pub crawl and moving on to the next pub in the street only to find themselves back where they started.

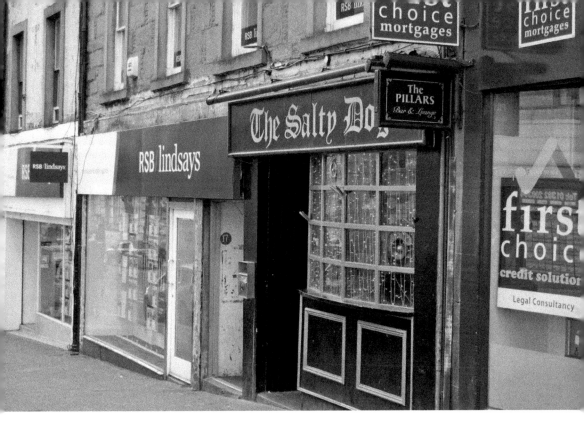

Above: The Salty Dog.

Below: Inside the Salty Dog.

13. Draffens, Couttie's Wynd

Couttie's Wynd is a narrow lane that stretches from Nethergate to Whitehall Crescent. It is one of the oldest streets in Dundee and was a passage from the shore to the burgh before 1200. It takes its name from William Couttie, a butcher who had property there in the sixteenth century. Prior to this it was called Spalding's Wynd – named after David Spalding, who lived there and who represented Dundee in the Scottish Parliament of 1456–58. Today Couttie's Wynd is essentially a back alley, home to the things that the businesses with smart frontages on Whitehall Street want to keep out the way such as drainpipes, overflows and bins. It is not the sort of place that most people would choose to open a pub. It is, perhaps, though, some place that you might chose to hide something.

Draffens is a secret pub, a modern version of a 1920s speakeasy. There is no signage on the outside of the building. The first-time visitor may be unsure if they are in the right place, even as they open the door, adding to the prohibition-era feel. Checking their phone for the bar's presence on social media will not, of course, do any good. Once inside, they will go down a staircase and emerge into a stylish, atmospheric basement bar with cocktails on the menu in true 1920s style.

Draffens somehow manages to appear simultaneously old fashioned and modern, so it is perhaps fitting that the name of this relatively new Dundee pub should be a nod back to the city's past. Draffen and Jarvie's department store opened for business in Whitehall Street in 1889. George Draffen and John Jarvie had acquired the established business from Thomas Blakeney & Sons, who had moved there two years earlier. Jarvie retired in 1891 and the shop was known as Draffen's from then until it closed in the early 1980s. The building went on to become a branch of Debenhams, before they relocated to the new Overgate centre in 2000. It was later divided

Draffens: a trip back to the prohibition era.

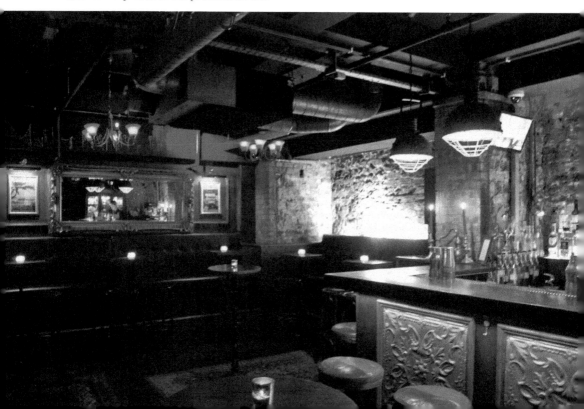

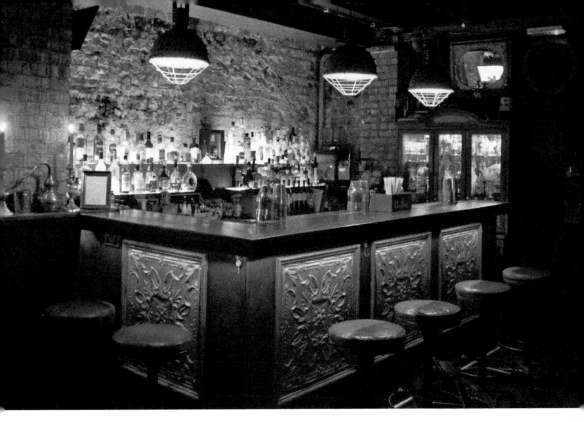

The bar in Draffens.

into smaller units. Old signs in Whitehall Street still recall 'Draffens of Dundee', but the name of the pub is also now helping to keep the name, ethos and sense of style of this fondly remembered Dundee institution alive, albeit in its own secretive way.

14. The Trades House, Nethergate

William Moon and John Langlands set up a draper's shop in the Overgate in 1833. The shop was the first in Dundee to have set prices – prior to this the custom had been to barter until a price was agreed. The business was a great success and in 1842, Moon and Langlands moved to a new building, Albion House, at the corner of Nethergate and Union Street, where the business continued to expand. By 1887, it was owned by Thomas Blakeney. That year he moved to new premises that he called Blakeney's Buildings in Whitehall Street. This was the business that eventually became Draffens of Dundee. Albion House, meanwhile, became a bank and remained one for around a century.

A visitor to the Trades House Bar, which occupies the building today, would be forgiven for thinking that that this was a pub that dated from the 1890s rather than the 1990s. Many modern pubs have been fitted out in a late Victorian or Edwardian style, but few are as convincing as The Trades House. The reason for this is probably the degree of craftsmanship that went into the construction of the interior – quite appropriate considering that the pub celebrates various trades that have contributed to Dundee life.

Of particular interest are the various stained-glass windows. There are depictions of shipbuilding, journalism and engineering – all enterprises that have contributed to Dundee in relatively modern times; however, there are also windows showing a baker, a weaver, a dyer, a stonemason and a maltman – all representatives of trades with a long history in the city. Indeed,

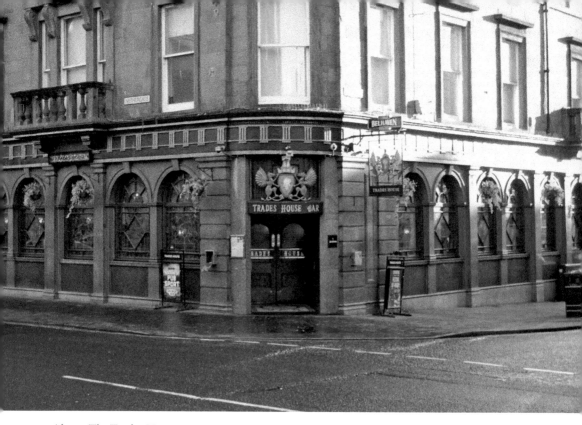

Above: The Trades House Bar.

Below: Inside the Trades House.

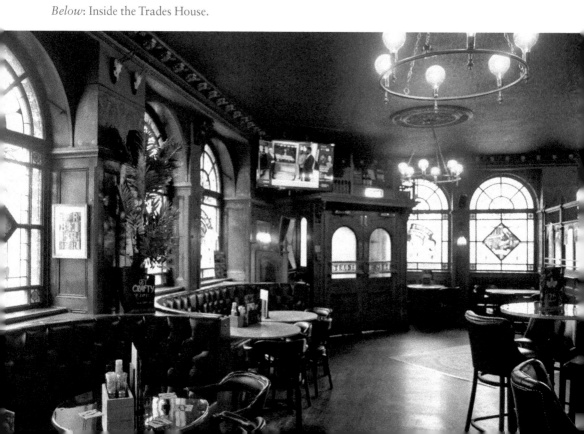

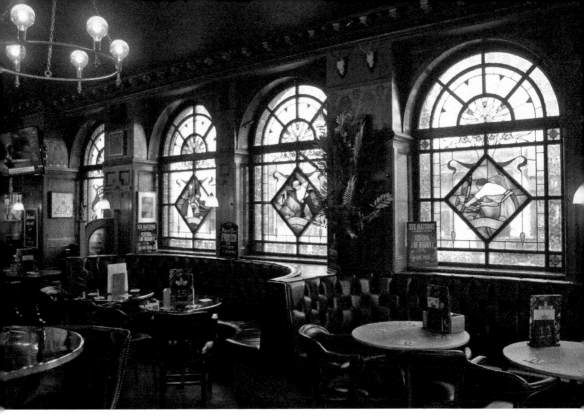

Above: The stained-glass windows showing different trades.

Below: Robert King at work in the Trades House.

the Bakers, Weavers and Dyers were three of the Nine Incorporated Trades of Dundee, which date back to the sixteenth century – the others being Cordiners (Shoemakers), Glovers, Tailors, Hammermen, Fleshers (Butchers) and Bonnetmakers.

15. Dynamo Dundee, Union Street

Brewery Six° North was established in 2013. Founder Robert Lindsay was inspired by Belgian beer culture and tradition and began brewing his own beers in Stonehaven (6 degrees north of Brussels) before expanding into the pub business. In late 2018, that pub business came to Dundee with the opening of Dynamo Dundee in Union Street, which offers an impressive twenty-four beer taps. While it might be a relatively new pub in one sense, it will soon become apparent to the visitor when they see the fine old bar and gantry or enter the panelled saloon bar that this is an older premises. Locals will recall it as the Star and Garter – a name it had for well over a hundred years.

In 1852, the wine and spirit business at Nos 42 and 44 Union Street, Dundee, was sold by a Mrs Grant. It was described as the 'well-known business established in 1835 by her late husband Lewis Grant'. Some earlier directory listings give other numbers in Union Street for Lewis's business, so it may be that it did not begin in the present Dynamo premises. Entries in the 1840s give the street number as 46. It may be that Grant relocated from the shop next door or it may be that the street was renumbered. Either way, the pub was certainly listed as No. 42 and/or No. 44 from at least 1850. Dynamo Dundee, then, can make a reasonable claim to be one of the oldest pubs in Dundee – as well as one of the newest.

Dynamo Dundee, formerly the Star and Garter.

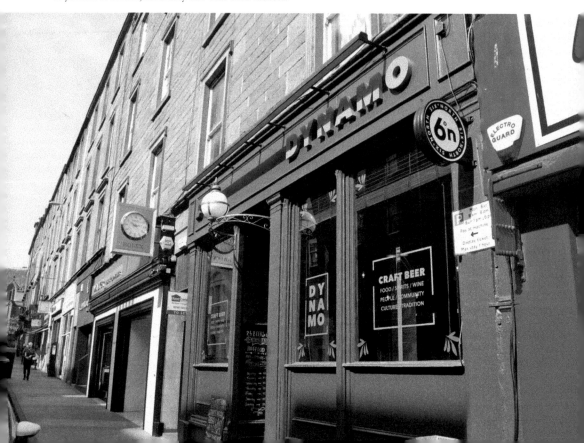

16. The Club Bar, Union Street

In late 1853, an advertisement appeared in the Dundee press: 'William Simpson Spirit-dealer has Removed from the Murraygate to that Commodious Shop, No 47, foot of Union Street. Wines, Spirits, Porter and Ales, for family use, of the finest quality.'

This 'commodious shop' still welcomes customers as a public house. Once known as the Great Western Bar, it has been familiar to more recent generations as The Club Bar. It is the first pub that a visitor to Dundee will encounter when walking from the railway station. Indeed, a raised pedestrian walkway from the station once deposited the traveller immediately outside the pub. Before this, it was close to the now demolished Dundee West station and had long been convenient for visitors arriving by boat.

In 1889, a respectable-looking couple arrived at Dundee docks and took up lodgings at No. 43 Union Street. They only stayed at this address for just over a week and went into the pub almost every day. The man always ordered beer for himself and often for his wife – though she occasionally took a port wine. They never appeared to mix with other customers. The man told the bar manager that they had come from London for the sake of the woman's health and implied that they both had a private income. In fact, they had little or nothing.

Barely two weeks after her arrival in Dundee, the woman – Ellen Bury – was dead, murdered at the couple's new lodgings in Princes Street. Her husband, William Henry Bury, was found guilty of the crime and condemned to death, later becoming the last man to be hanged in Dundee. At the time of his arrest, he told the police he was worried that people might think he was Jack the Ripper. Some believe that this is precisely because he was indeed the notorious serial killer.

The Club Bar – Jack the Ripper's local?

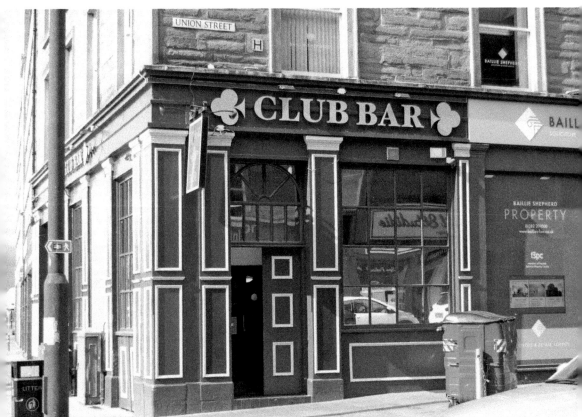

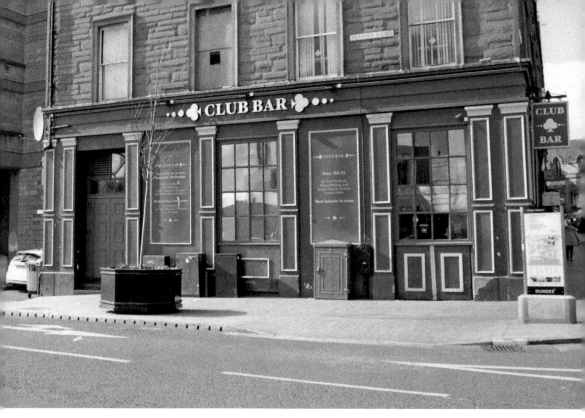

The Club Bar from Yeaman Shore.

Bury had come to Dundee from the East End of London where he had worked as a sawdust merchant at the time of the Ripper murders. After he left there were no further murders. Unlike other suspects, Bury was a proven murderer and was deemed to have mutilated his wife's body after her death in a way that bore similarities to the horrific injuries suffered by the Ripper's victims.

It seems likely that the killer's true identity will never be known, but few visitors to the Club Bar today will be aware that they are drinking in what might possibly, for the briefest of periods, have been Jack the Ripper's local.

17. The King of Islington, Union Street

William Bury is also believed to have visited the other public house in the same tenement as his lodgings, which was located at No. 39 Union Street. More recent visitors will recall this pub and its basement as the Union Bar or the Angus Bar and the Rendezvous. Others will remember when the landlord was the former Dundee United player Davie Dodds. Dodds signed for United as a youngster and went on to be part of the team that won the Scottish Premier Division in 1982/3 under manager Jim McLean. He scored a total of 150 goals for the club.

Today the premises at No. 39 Union Street is home to the King of Islington, a small, stylish bar specialising in rum and cocktails. The bar has an impressive selection of more than 120 rums and sugar cane spirits from Central and South America and has won two Scottish Licensed Trade News awards.

The King of Islington is also continuing Dundee's long association with rum. In 1838, a successful Bathgate draper George Morton was standing at Dundee's docks when he saw ships

Above: Inside the King of Islington.

Below: Dimi mixes a cocktail at the King of Islington.

arriving from the colony of British Guiana laden with casks of Demerara rum – a rich dark rum unlike the lighter Caribbean rums that had been available previously. Morton was so intrigued that he bought a barrel. He later established his own rum business in Dock Street near where he had first seen the rum unloaded. Morton's Old Vatted Demerara (OVD) rum soon became one of the country's most famous brands.

18. Clarks on Lindsay Street

Clarks on Lindsay Street is one of Dundee's top live music venues and has played host to many well established and up and coming acts as well as a variety of popular cover bands. The building that contains Clarks was not always a pub, though. It was built in 1874–75 as Lindsay Street Mill by local architects MacLaren & Aitken for the firm of John Henderson & Sons. In 1931, it was sold to Brown Brothers who occupied it for the next fifty-one years.

The credit for spotting the premises' potential as a pub must go to the local newsagent whose shop was at No. 72 North Lindsay Street. If that was his only contribution to Dundee life then music fans at least would still have cause to be thankful to him, but this newsagent – Marshall Key – was also one of the city's greatest ever sportsmen.

Marshall Whitton Key was born in Dundee in 1932. As a child his family home was at No. 240 Kingsway, a few hundred yards from the city's original ice rink where he used to go skating with his mother and sister. He once recalled, 'I was dragged off to the ice rink with them. I had to go as it was a night that my Dad went to the pub!'

Spotted by coach George McNeil, he began playing ice hockey progressing to the junior Dundee Rockets team aged thirteen and the senior Dundee Tigers at age sixteen. He went on

Clarks on Lindsay Street.

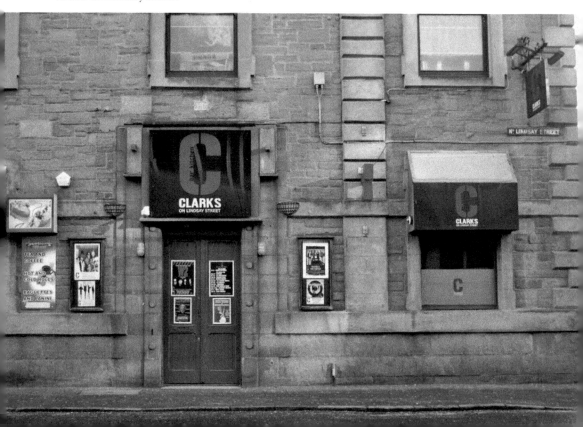

The former mill building, which contains Clarks.

to play a total of more than 500 professional games for Dundee Tigers, Harringay Racers, Edinburgh Royals and Paisley Pirates and scored 217 goals as well as 332 assists. He later came out of retirement to coach the reformed Dundee Rockets.

In 1962, Marshall Key had taken over his father's shop. Twenty years later he and his wife Doreen bought the Brown Brothers premises. They sold off the upper floors, but transformed part of the ground floor into a pub they called The Keyhole – a play on their surname that also came with an obvious logo and a slogan, 'Look into the…', followed by the keyhole symbol.

After selling the Keyhole in 1987, Marshall Key ran the Invergowrie Inn. In 2000, he performed the opening ceremony for the Dundee Ice Arena, where one of the function suites is named after him. He was entered into the British Ice Hockey Hall of Fame in 2008 and died in 2016.

2

The West End

For the purposes of this book, a wide interpretation has been taken of what constitutes Dundee's West End: anything west of the West Marketgait dual carriageway. This road has become a natural border, having sliced through the city's traditional street pattern, leaving the West Port bereft of the connection that it once had with the Overgate and Marketgait and the western part of the Nethergate more associated with the start of the Perth Road than with the other section of the same street across the dual carriageway. This is an affluent area and also a somewhat bohemian one, being home to the main University of Dundee campus and Duncan of Jordanstone College of Art and Design as well as the Rep Theatre and the Dundee Contemporary Arts Centre.

Some part of the West End did not suffer to the same extent as other areas of Dundee from the spate of demolitions that plagued the city in the 1960s and 1970s, but construction of the university and new roads did severely affect the Hawkhill (now known as Old Hawkhill), which once stretched from the West Port to the Sinderins. While part of the street still exists, the thriving community with its numerous shops and bars that some in Dundee still remember does not. A few pubs survive, nestled at either end of the street: The Tinsmith (once the Tally Ho!) and the Underdog (historically known as Mickey Coyles) at the West Port end; the Hawkhill Tavern and the Campbeltown Bar at the other end. Other pubs hung on bravely for years, despite the destruction going on around them and many will still remember The Sinderins, Frew's Bar and the Tavern.

Despite the loss of some old favourites, our West End pub crawl will still take in some of Dundee's longest established pubs.

19. The Beer Kitchen, South Tay Street

The Innis & Gunn brewing company was founded in 2003 by Dougal Gunn Sharp. It has since expanded to be one of Scotland's most successful craft brewers, exporting to more than thirty-five countries. After a successful launch in Edinburgh, the company's Beer Kitchen concept – combining, as the name suggests, beer and food – came to Dundee in 2016. Among the notable features are an exposed beer cellar and two 500-litre tanks serving fresh beers straight from the Innis & Gunn brewery in Perth.

The Beer Kitchen is located at No. 10 South Tay Street, a building that dates from the early part of the nineteenth century when the street was laid out by city architect David Neave. Originally

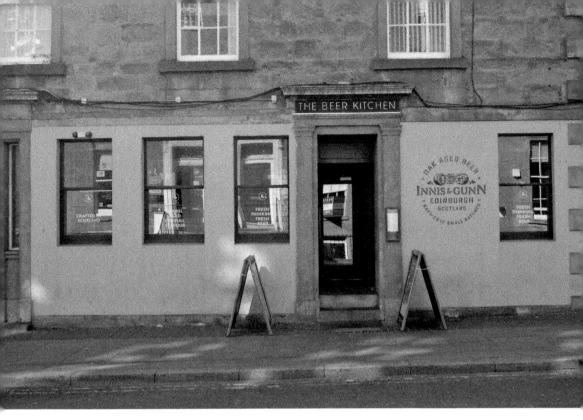

Above: The Beer Kitchen, South Tay Street.

Below: The Beer Kitchen from Tay Square.

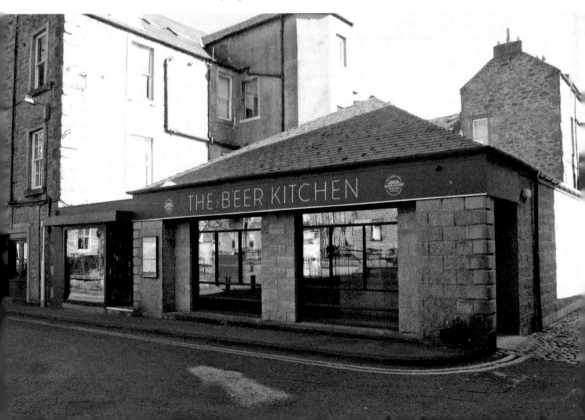

a private residence, for around a century from the mid-1870s a visit to No. 10 South Tay Street was not perhaps as welcome as it would be today. In this period it operated as a dentist's practice.

After opening as a pub the premises was known as No. 10 for many years, and was one of the few city centre pubs to have a beer garden. The name came from the street address, but also brought to mind the prime minister's official residence in Downing Street, making it one of three in the area that had a politically themed name. Chequers (the prime minister's country residence) was around the corner in the Nethergate, while further along the same street at one time was the Parliamentary Bar (now the Nether Inn).

20. Tom's Pacific Cocktail Parlour, Temple Lane

Town plans from the mid-nineteenth century show a pub in Temple Lane and another around the corner in West Port. These were replaced by a new tenement building towards the end of that century, which contained a pub that was at one time known as the Temple Bar. This pub is more likely to be remembered in Dundee today as the Scout. The entrance to the Scout was on Temple Lane, while the shop on the corner (then known as No. 30 West Port) was given over to various uses over the years. In the 1970s it was home to a business named Hobbies and Handicrafts

The Scout took its name from landlord Oliver Hamilton (known to many as Vic) and reflected the fact that he had been a full-time scout for Blackpool FC. Sadly, Hamilton died suddenly in 1971 at the age of fifty, but the pub remained in the family after this and was popular until its closure in 1982.

In 1983, brewing returned to Dundee with the opening of the Hawkhill Brewery, which was set up in an industrial unit near the university. The Hawkhill Brewing Company took over and

Tom's Pacific Cocktail Bar.

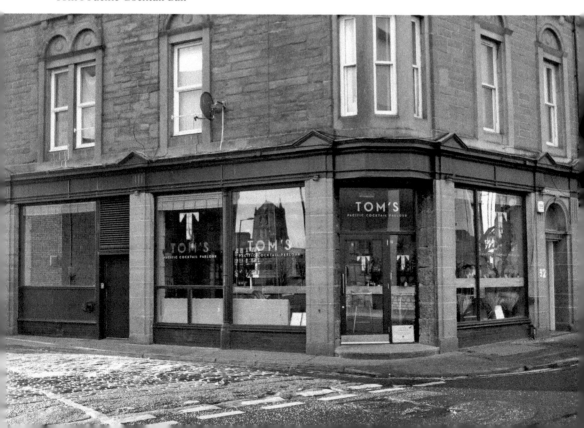

refurbished the Scout and the corner shop and opened it as a pub called Bally's named after the new enterprise's main product – an ale called Old Bally. Sadly, the new brewery did not last long and the pub has had various guises over the years, including The Boudoir, and is now Tom's Pacific Cocktail Parlour.

21. Molly Malone's, West Port

In 2019 the pub at Nos 53–57 West Port underwent a successful refurbishment. There was a degree of controversy, however, when it was announced that the much-loved venue was to become an Irish-themed bar and renamed Molly Malone's, abandoning its traditional name of the Globe in favour of that of the fictional Dublin fishmonger from the ballad of the same name. The Globe name had been adopted more than a century before and indeed in the late nineteenth century – a pub sign in the form of a globe was fixed to the Hawkhill side of the pub.

The landmark building that contains the pub dates from 1823, while the public clock was added in 1864. For most of its existence the Globe Bar only occupied the left-hand side of the ground floor (No. 57) while the other parts of the ground floor (Nos 53 and 55) had various occupants, including a grocer, an ironmonger and latterly a dry-cleaning firm.

By the late 1970s, the building had fallen into disrepair. It was perhaps fortunate not to have been demolished along with the Overgate and other parts of the West Port or much of the nearby Hawkhill in this period. In 1969, along with much of the surrounding area, it had come into the ownership of Dundee University and so, if not demolished, could conceivably been turned over to university use, but it was instead sold on. It was refurbished in the 1980s and the pub extended to cover the entire ground floor.

Molly Malone's, West Port.

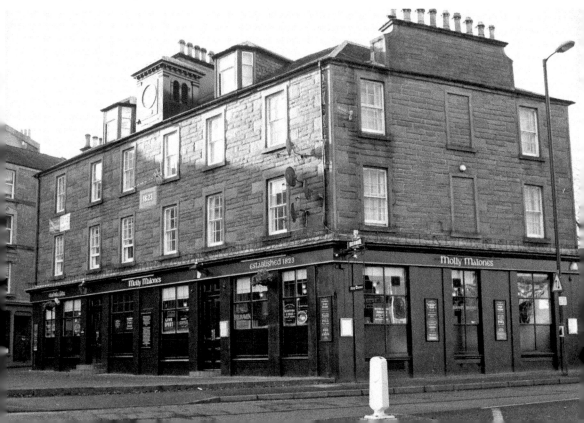

The Globe's sign is visible in this nineteenth-century view.

22. The Phoenix, Nethergate

The phoenix is a legendary bird that features in Greek, Roman and Egyptian mythology. Just before the end of its long life it was said to set fire to its nest and die in the flames. A new phoenix, though, would rise from the ashes. To most people in Dundee, however, The Phoenix is a pub in the Nethergate.

Above the pub's door is an image of the legendary bird while the word 'phoenix' in the Greek alphabet appears on the outside of the building. The Phoenix does not owe its name to the myth, though, but to a corruption of the name of its original owners – the Fenwicks.

In 1866, Peter Fenwick was granted a licence for the premises at No. 85 Nethergate. By 1869 he was listed in local directories at Nos 97–99 Nethergate. In 1880, Fenwick left to take over the Newport Hotel in Fife, leaving his son Peter to take over the business at the Nethergate. When Peter Fenwick Jr applied for his routine licence renewal in 1889, however, the local licensing board was reluctant. The pub's back room came in for particular criticism – it was said to be dark, the ceiling low and the ventilation defective. Bailie Perrie proposed that the licence be granted on the condition that the pub either be remodelled or new premises sought. Fenwick opted for the latter and in 1890 moved to a new building at Nos 103–105 Nethergate – the site of The Phoenix today.

The pub remained in the ownership of the Fenwick family until 1968. It was later renamed The Town and Gown to reflect its position between the university and the city centre, but like its mythological namesake, The Phoenix name rose again from the ashes and was readopted. The present owner, Alan Bannerman, bought the pub in 1987.

There is a persistent story that Frank Sinatra once drank in The Phoenix. If he did, it would have been on the evening of Wednesday 8 July 1953, when he travelled to Dundee from Glasgow

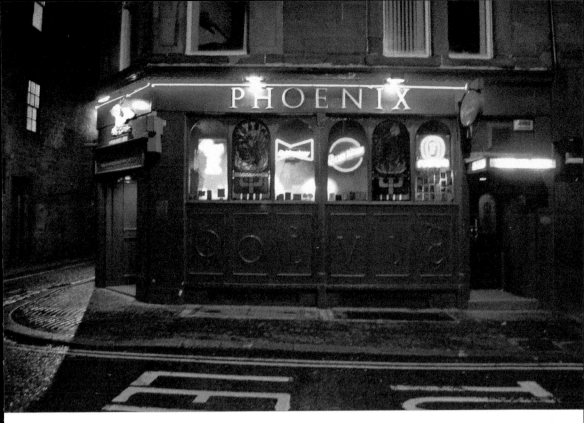

Above: Night-time at the Phoenix.

Below: The Phoenix sign with a quote from poet Robert Frost.

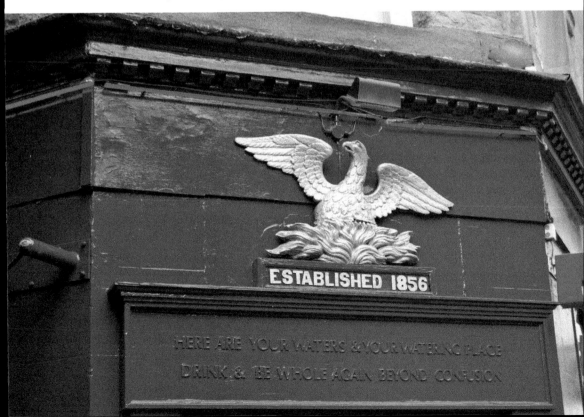

ESTABLISHED 1856

HERE ARE YOUR WATERS & YOUR WATERING PLACE
DRINK & BE WHOLE AGAIN BEYOND CONFUSION

and stayed overnight at the Queen's Hotel before watching the British Open Golf Championship at Carnoustie the following day. He played the Caird Hall the following week, but did not stay in Dundee then. Given the hotel's proximity to The Phoenix, there is every possibility that 'old blue eyes' popped in for a drink (and possibly even one more for the road).

23. No. 172 at the Caird and Capone's, Nethergate

Dating from around 1840, the townhouse at No. 172 Nethergate (once known as Caird House) together with the neighbouring property (Caird Cottage) at No. 170 and garden grounds to the rear were donated to the community by industrialist Sir James Key Caird, who also gave the city the Caird Hall and Caird Park. It opened in 1912 as Caird Rest and was designated to be used 'for the purposes of a place of rest and recreation for aged persons'. When it eventually ceased to be used for this purpose, the building came into the ownership of Dundee University before becoming a bar and restaurant in 2016.

No. 172 at the Caird currently houses three bars and lounge areas, with a separate restaurant, reception and cocktail bar on street level as well as a beer garden terrace to the rear. In 2018, permission was given to open a 1920s-style speakeasy in the building. It is named Capones Speakeasy Bar and Diner after Al Capone, the Chicago-based Italian-American gangster and businessman who gained notoriety during the Prohibition era. It is entered through a secret entrance to the side of the building. The décor in the bar brings the era to life while a jail cell reminds the visitor as to how Capone's career of crime ended when he was jailed, for, of all things, tax evasion.

No. 172 at the Caird.

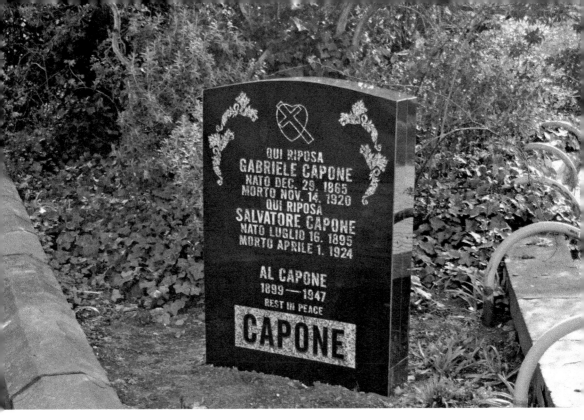

Al Capone's last resting place?

As to Al Capone's ultimate fate, you might notice his gravestone in the grounds, but he is not, of course, buried in Dundee. After his death in 1947, he was buried at Mount Olivet Cemetery in Chicago, but in 1950 his remains and those of other family members were moved to Mount Carmel Catholic Cemetery, Hillside, Illinois.

24. The George Orwell, Perth Road

The premises that today make up the George Orwell have been a public house since the early twentieth century. Prior to this, they consisted of two shops and were used for various purposes including a butcher's, an umbrella shop and a booking office for (horse-drawn) coaches.

For many years this pub was known as the Grosvenor. Its name was changed to the Tavern after Graehme Philip, the landlord of the pub with that name in the Hawkhill moved there after the original pub closed its doors. In more recent years, the Perth Road pub was known as Clancy's Irish Bar before becoming the George Orwell.

George Orwell, who was born Eric Arthur Blair in 1903, was a novelist and essayist best known for works including *Animal Farm*, *Nineteen Eighty-Four*, *The Road to Wigan Pier* and *Homage to Catalonia*. Such is the power of his work that the word 'Orwellian', referring to a totalitarian political system and phrases of his such as 'Big Brother' and 'Room 101' have entered the language. He is undoubtedly an important literary and cultural figure, but why is there a pub named after him in Dundee, a city with which he has no apparent connection? The answer is that Dundonian Mark Usher formerly ran a pub called the George Orwell in Islington, London, an area in which Orwell had once lived. When he returned to Dundee, he brought the name of his former pub to the Perth Road premises, just as his predecessor, Graehme Philip, had done many years previously.

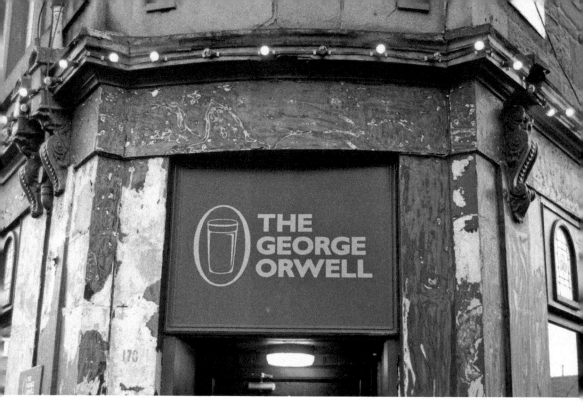

Above: The George Orwell.

Below: Inside the George Orwell.

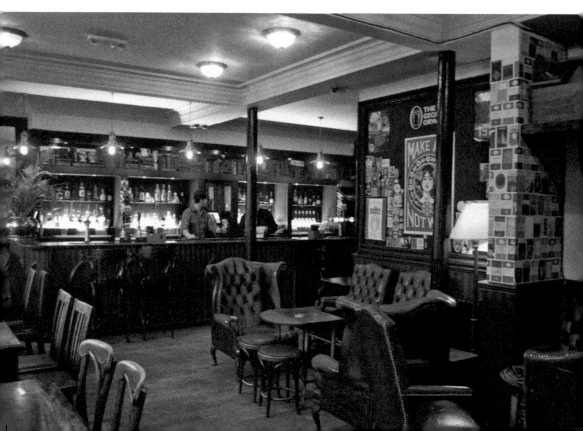

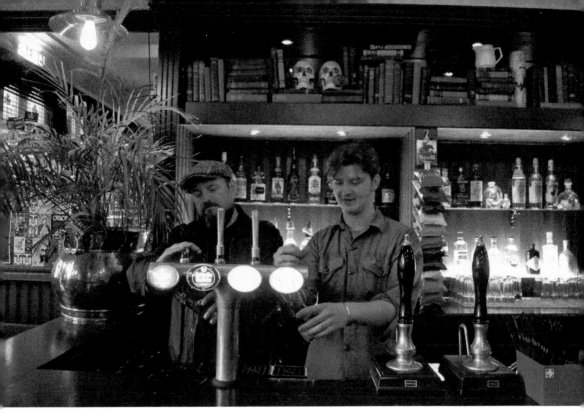

The George Orwell's landlord Mark Usher and bar manager Matt McDevitt.

The Orwell name and literary theme fit well with the university area in which the pub is situated and the atmospheric interior is pieced together with books and memorabilia, including posters recalling Orwell's involvement in the Spanish Civil War. Many from Dundee also took part in that conflict, fighting in the International Brigades. There is a memorial in Albert Square to those who died.

25. The Taybridge Bar, Perth Road

In the late nineteenth century, James Anton was the licence holder of a public house at No. 131 Perth Road. In 1889, he successfully gained the licence for the premises next door at Nos 127–129 Perth Road, which became the Tay Bridge (or Taybridge) Bar. The bar, of course, takes its name from the railway bridge that spans the River Tay and which had opened two years earlier. This, of course, was not the original rail bridge; that had collapsed during a ferocious storm in December 1879, with the loss of a train and all its passengers and crew.

The Taybridge bar originally consisted of three rooms – a bar, a lounge and a snug. The most famous of these is what became known as the Walnut Lounge due to its walnut veneer panelling. The pub has now been opened out into a single, long, wide room. The twenty-first century renovation, though, has been done tastefully and under strict conditions, with much of the pub's original character retained. (It is perhaps fortunate that the remodelling was not attempted in the 1970s.) Many features survive, including the original gantry with its two large mirrors – one showing the Tay Bridge itself and the other advertising Younger's Beers. There is also a smaller mirror to the left of the bar. This one promotes 'Yellow Label' – a once popular whisky produced by the Dundee firm of John Robertson & Son.

Above: The exterior of the Taybridge Bar.

Below: The Walnut Lounge.

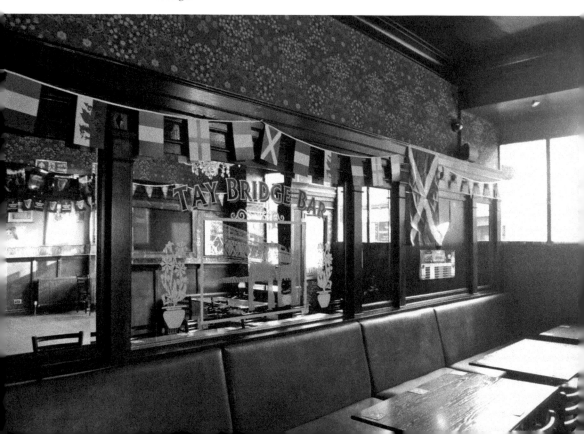

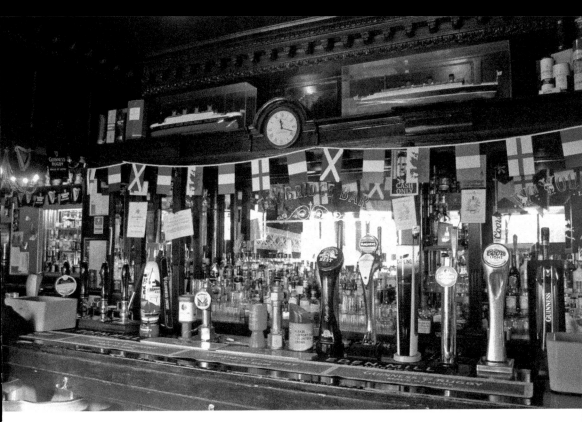

Above: The bar and mirrors.

Below: Frida Kahlo takes her place in the Taybridge Bar.

The Taybridge Bar has become well known far from Dundee thanks to a song written by the late Dundee musician Michael Marra called 'Frida Kahlo's visit to the Taybridge Bar', which appears on his album *Posted Sober*. Frida Kahlo was a painter known for her works inspired by the nature and culture of her native Mexico. Her reputation as an artist has only grown in the years since her death in 1954. Unlike Michael Marra himself, Frida Kahlo did not actually visit the Taybridge Bar during her lifetime. Indeed, Marra does not claim that she did as the song is set after her death and involves her being sent there by St Peter on her way to Heaven. In 2013, several of Michael Marra's family and friends, including his widow Peggy and children Alice and Matthew, visited the Taybridge Bar for the presentation of a print of his montage painting entitled *Frida Kahlo's Visit to the Howff*, which is now proudly displayed there.

26. The Speedwell Bar (Mennie's), Perth Road

William Speed was born in Dundee's West End, where his father George was a dairyman who used to graze his cows on the Magdalen Green. In 1844, William Speed got a grocer and spirit dealer's licence for premises in Perth Road before becoming publican there. He also ran the Western Hotel, which was situated just to the west of the present Speedwell Bar.

In 1875, Speed expanded the family enterprise to include his son James, but four years later they successfully convinced the licensing court that business in Perth Road was not sufficient to maintain father and son, and James was granted his own licence elsewhere. When William Speed died in 1898, however, James came back to the Perth Road to take over the pub there.

The Speedwell Bar, otherwise known as 'Mennie's'.

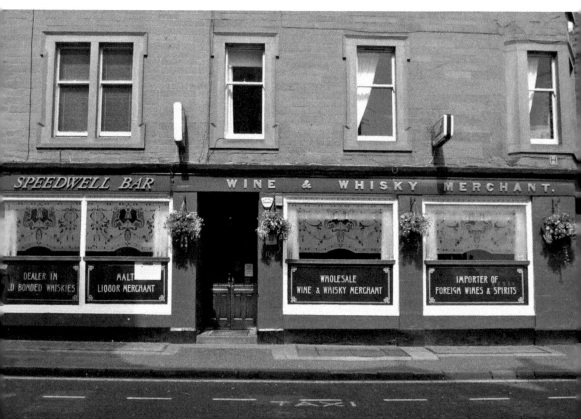

In 1903 James Speed was given permission to transfer his licence next door to new premises that he had had built. This is the Speedwell Bar as we know it today. The Speed part of the name obviously comes from the landlord's name; the 'well' from a nearby well.

The pub today is remarkably unchanged from Speed's day and is considered one of the country's finest surviving examples of an Edwardian pub, earning it status as a Category B listed building. The exterior plate glass windows are etched with the same art nouveau design that appears on the glass of all the internal doors and screens. These screens help to break up the L-shaped mahogany bar and allow customers chatting at the bar some privacy from their neighbours. The impressive gantry contains over 150 malt whiskies. To the side of the main bar are two lounges separated by a glazed screen, each with original panelling and features. Even the gents' toilet retains the original Shanks fittings, tiles and mosaics.

James Speed died in 1923 and the premises were put on the market. The new tenant was Henry Mennie, who had begun his career in 1901 as an assistant to Speed. The pub has been known as 'Mennie's' ever since. In 1946 the licence was transferred to Henry Mennie's son Ian and four years later to Ian's wife Isabel – the legendary Mrs or Ma Mennie whose name is preserved today in the pub's notice board – 'Mrs Mennie's Notices'.

Although the Mennies had been the pub's tenants since 1923, it was not until 1965 that Mrs Mennie bought the property from the Speed family for the sum of £6,000. She retired in 1976. In 1995 the Speedwell was bought by Jonathan Stewart and, having been run by two generations of Speeds and two generations of Mennies, it is perhaps fitting that it is currently run by his son Jonathan.

The Speedwell's Edwardian interior.

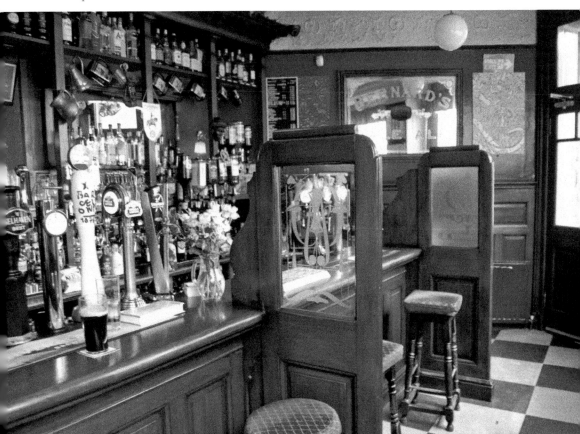

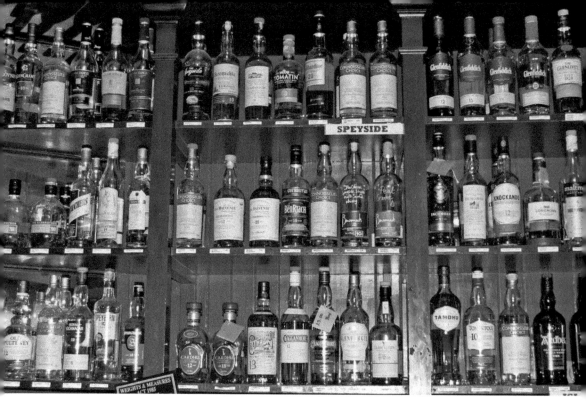

Above: Part of the Speedwell's famous gantry.

Below: The back lounge at the Speedwell.

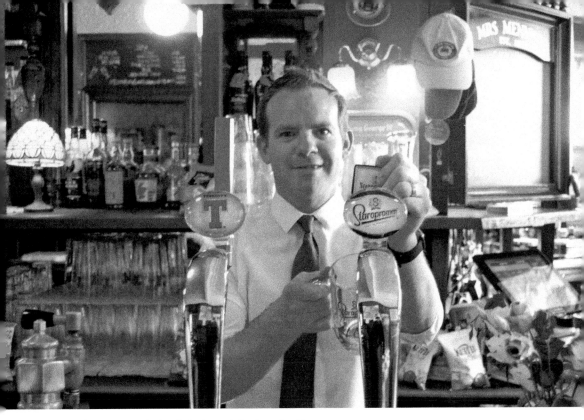

Jonathan Stewart behind the bar of the Speedwell.

27. The Balgay Hill Bar, Rosefield Street

Commonly known as the Rosie Bar, this pub is unusual as it takes its nickname from the name of the street in which it is situated – Rosefield Street – rather than its official name of the Balgay Hill Bar or the name of a landlord. Rosefield Street itself takes its name from a house known as Rosefield Cottage, which had previously occupied the site and, presumably, had an impressive rose garden. When the pub first opened in 1877 it was known as the Balgay Bar. This might seem a strange choice, but it is important to remember that the view towards Balgay Hill would have been much more open at this time as most of the other side of Rosefield Street and the Logie Housing scheme had not yet been built.

The Rosie narrowly missed being destroyed during the Second World War. On the night of 5 November 1940, eight bombs were dropped on Dundee, one of which landed on Rosefield Street. The bomb destroyed an entire tenement and killed two people. The tenement – at No. 19 – was later rebuilt. Visiting the street today, however, it is still possible to see the difference between the replacement building and the surrounding ones.

In 2015 the Balgay Hill Bar made history when a couple were married on the premises. A change in the law as to where civil marriages could take place meant that Nikki Newberry and Larry Scott could marry the in place where they had met four years previously.

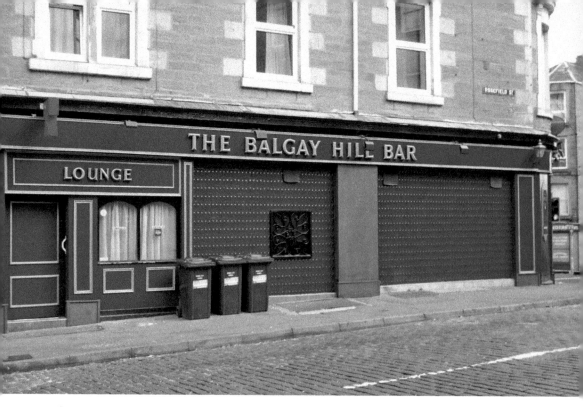

Above: The Balgay Hill Bar from Rosefield Street.

Below: Another view of the 'Rosie'.

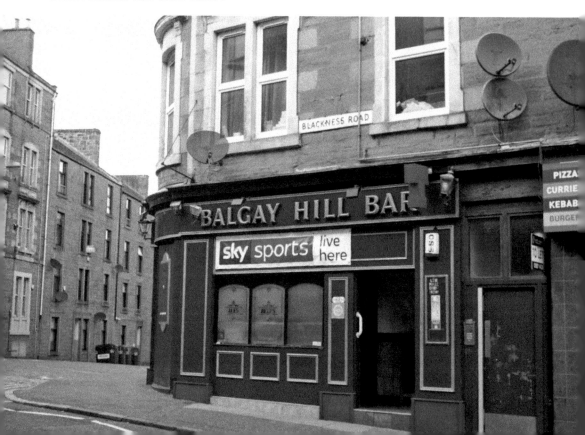

3

The Road to Lochee

Lochee started out as a small settlement of weavers that grew up along the banks of a burn. With the expansion of the jute industry in the nineteenth century, it grew to be a substantial village and eventually became part of Dundee in 1859. Densely populated streets and large numbers of thirsty millworkers meant that the area was home to a number of pubs. More recent trends, however, have seen pubs move away from the High Street. Several pubs in the area that were open within living memory have now vanished altogether. Among these are the Railway Tavern (now converted to housing) and the Old Toll Bar (demolished and many of its fittings transferred to the collection of Dundee's museum).

A relatively recent closure is the Sporting Lounge, which has now been converted into a food outlet. Its history goes back to the late nineteenth century when David Watson held a licence for premises at No. 96 High Street, while in 1882 the Scottish Banking Company opened a branch next door at No. 94. Watson eventually ended up with both premises and the pub became known as the Old Bank Bar. By the time of the Second World War the landlord there was Alexander McReddie. In 1942, his youngest daughter, Alexina, married Stefan Koziol, a member of the Polish navy. Alexina took over the running of the pub in 1944 with the result it became known as Koziol's, which quickly mutated into the local nicknames of Cozy Holes or the Cozy Hole. Following a fire in 1959 the pub was rebuilt and reopened as the Silver Tassie before ending its days as the Sporting Lounge and the Olympic Suite.

The side of the High Street that once contained the Sporting Lounge was subject to major redevelopment in the 1970s. This saw the disappearance of both Smith's Bar and the Crown Bar. Meanwhile, the South Road area lost the Corner Bar, Bodies, the Ivanhoe (later reopened on the High Street) and the Central Bar. The Central Bar was run by James Brownlee, who subsequently opened the Planet on South Road. The Planet was the site of an important innovation in Dundee's pub business. In 1977, Dundee's licensing court voted by six votes to four to allow what was then termed 'Continental-style' drinking on the pavement outside the pub. Commonplace today, the move was controversial at the time and faced opposition from Lord Provost Charles Farquhar among others. Councillor Percy Starling said that he did not think that Scotland was ready for such a move. Councillor William McKelvey, however, described it as a 'novel and courageous idea'.

While this chapter is principally concerned with Lochee, we will, in true pub crawl style, stop off at a couple of places on the way…

28. Duke's Corner, Brown Street

The building that today houses Duke's Corner began life as a school, and customers enjoying a drink in the beer garden are actually sitting in what once was the playground. The school was initially associated with the Free Church of Scotland and dates from the time of that institution's formation in 1843 when it broke away from the established Church of Scotland in what was known as 'the Disruption'.

At the time of the 1872 Education Act, the Free Church handed its schools over to the state and it was in this period that the school – now known as Brown Street Public School – saw an extension added to the front of what had previously been a plain, rectangular building.

A plaque on this section of the building commemorates Lila Clunas (1876–1968), who was a teacher at the school and a leading member of the campaign for votes for women in Dundee in the early twentieth century. She was involved with the suffrage movement from 1906 when she joined the Women's Social and Political Union and was later secretary of the Dundee branch of the Women's Freedom League. In 1908, she was ejected from one of Winston Churchill's by-election meetings for heckling, and a year later she was jailed in London. She had been part of a delegation that presented a petition to Prime Minister Herbert Asquith in Downing Street. Some reports have her attempting to hit Asquith, but the actual charge was 'obstructing the police in the discharge of their duty'. While in prison, she went on hunger strike and was released early. From 1943 to 1964 she was a Labour councillor in Dundee.

Brown Street School has had several incarnations as a pub, but it was as The Doghouse in the first decade of the twenty-first century that it became well known outside Dundee. The name brings to mind the expression 'in the doghouse', but also the fact Brown Street had

Duke's Corner – the former Brown Street School.

The Duke's Corner beer garden.

long been home to Dundee's council kennels. The Doghouse quickly gained a reputation for live music, particularly among young people. Most notably, The View, one of Dundee's most successful bands, who had taken their name from another Dundee pub, the Bayview, made it their second home. Indeed, having been given use of the upstairs rehearsal room, they spent so much time there that in some respects it was their first home for a period, before success took them further afield.

29. Beiderbecke's Bistro and Cocktail Bar, Brook Street

Beiderbecke's Bistro and Cocktail Bar may no longer be a traditional pub as such but earns its place in this book as it is the last survivor of the many drinking establishments that once lined Dundee's Brook Street. The street's name is a twentieth-century Anglicised version of its earlier name – Scouringburn – which, in turn, reflected the name of the Scourin' Burn, which once ran through the area but is now piped underground. The burn had powered some of Dundee's earliest mills.

In the mid-nineteenth century, in the wake of the failure of successive potato crops in Ireland, the Scouringburn area became heavily populated with Irish immigrants who had come to work in these mills. It retained an Irish character into the twentieth century and this was reflected in the names of some of the pubs such as Owen Lynch's, the Celtic Bar, the Shamrock and the Harp Bar. Not every pub name reflected this heritage, though; other bars included the Royal Bar, the Black Watch and the Union Jack. In the late 1850s, there was an Inkerman Tavern, which took its name from the Battle of Inkerman, which had been fought on 5 November 1854 during the Crimean War.

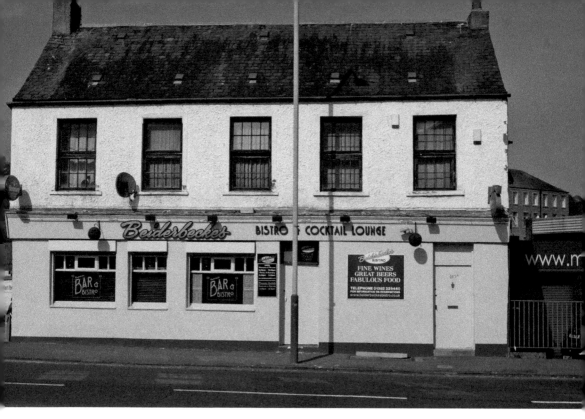

Beiderbecke's Bistro and Cocktail Lounge, Brook Street.

For much of its lifetime, what is now Beiderbecke's was known as The Royal Oak. This is a common pub name, taken from the tree in Boscobel Wood in which Charles II hid to escape the Parliamentary Army following the Battle of Worcester in 1651. There was no obvious link to the area around Brook Street in Dundee, but Charles had stayed at nearby Dudhope Castle in 1650.

The premises at No. 167 Scouringburn have been associated with the alcohol trade since around 1840 when it was home to Donald Campbell, a brewer. As happened elsewhere in Dundee, the public house evolved out of the small brewery he ran there.

In the latter half of the twentieth century the area became depopulated and mostly given over commercial and industrial purposes, leaving the Royal Oak somewhat isolated, though more recent years have seen residential property return. Over the years the pub's name changed to the Scouringburn and Shoestrings and back to the Royal Oak before adopting its current name in honour of Leon Bismark 'Bix' Beiderbecke a cornet player who was one of the most influential jazz musicians of the 1920s. The interior walls are decorated with pictures of him and other musical heroes.

30. Bissell's Bar, Polepark Road

There was once a field, part of the Logie Estate, which contained a large pole with a gilded ball on top, earning it the name 'The Pole Park'. The name later passed on to Polepark Road, the street built on the site and ultimately to The Polepark Bar.

Even though this was the pub's official name for many years, locals would refer to it as Bissell's. This is not, perhaps, surprising given that it was run by the Bissell family for some

Bissell's Bar and Lounge, Polepark Road.

fifty-seven years. William Bissell was born in Dundee in 1917. He started out as a baker before joining the Royal Navy as an engineer, serving during the Second World War. He left the navy in 1950 and had various other jobs before taking over the Polepark Bar in 1957. He and his wife Margaret had four sons, each of whom entered the licensed trade. After his retiral, one son, Alastair, ran the Polepark Bar for a further twenty-five years, before finally calling time on the family's tenure in 2014. Willie Bissell himself died in 2012 at the age of ninety-five.

The pub long predates the Bissells, though, having first opened its doors in the early 1870s. Some evidence of this long history came to light when a collection of mugshots and descriptions of people who were barred from the local pubs dating from 1905 was discovered on the premises. Anybody convicted under the Inebriates Act of 1898 three times in the space of twelve months could be added to this list. Publicans faced heavy fines for serving any of them. Some would not have been difficult to spot. The descriptions include distinguishing marks such as 'left eye awanting' and 'wanting teeth'. These documents were later sold at auction for £1,500.

When the late and much-missed Dundee singer-songwriter Michael Marra was looking for inspiration for a song for the Dundee women's choir Loadsaweeminsingin, he used the story of the mugshots (or 'unwanted posters' as he called them) to produce a composite character that he called 'Muggie Sha'. The name (a Dundonian translation of Margaret Shaw) came from hearing his aunt mention an old acquaintance of that name. In the song's lyrics, Muggie is 'barred fae Bissell's', though the actual landlord at the time of the mugshots was one John Kennedy. Nevertheless, the poetic licence is justified as the pub's name has so long been fixed as Bissell's in the minds of local people.

31. Kelly's Bar, High Street, Lochee

In 1870, a licence was granted for a new public house at the premises at No. 89 High Street, Lochee. This pub became known as the Kimberley Bar. Next door at No. 91 on the corner of Burnside Street was a grocer's shop while the upstairs accommodation above both was given over to housing and accessed by a staircase to the rear. In 1910, the then landlord of the Kimberley, John Farley, was given permission to move his licence next door to the former grocery premises on the corner while the former pub reverted to being a shop.

In 1944, the pub's licence was taken over by George Hood and it gained a new name – the Robin Hood (the story goes that one of the locals had suggested this name as Robbin' Hood in a less than complimentary swipe at the landlord). Meanwhile, in the late 1930s, the original site of the Kimberley Bar next door at No. 91 High Street, having been home to a fruiterer and then a draper, became a barber's shop. The barber's name was Alexander Alexander, known locally as Double Ecky. This shop eventually became part of the pub and was originally known as the Maid Marion Lounge, while the two upstairs flats, having been combined into one, became

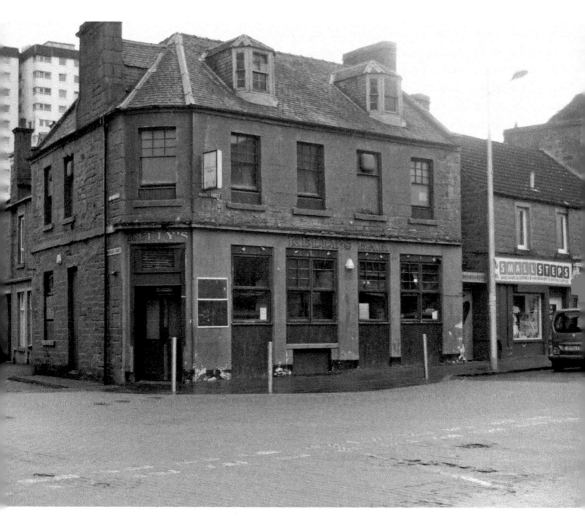

Kelly's Bar in Lochee High Street.

another lounge known as the Sherwood. In the early days, this lounge could only be accessed by the original outside stair for the flats.

In more recent times, the pub has been known as Kelly's after spells as the Corner Bar Ellen Shannon's and J. R.'s Bar.

32. The Last Tram, High Street, Lochee

The pub at No. 144/6 High Street in Lochee has had several names over the years. In the nineteenth and early twentieth century, it was known as The Camperdown Tavern. This refers to the Battle of Camperdown, a famous naval victory by Dundee-born Admiral Duncan. Although it is likely that the name was more directly inspired by the nearby Camperdown Works, the premises of jute manufacturers Cox Brothers Ltd. The factory, which at its peak employed some 5,000 people, naturally supplied many of the tavern's customers.

At the time of the First World War, Cox Brothers gave over their 'half-timers' school in Bright Street to the Red Cross for use as a hospital. The proximity of the Camperdown Tavern to the

The Last Tram pub, Lochee.

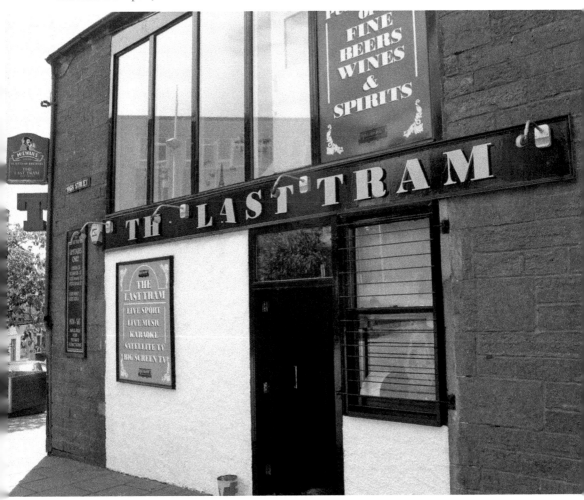

hospital meant that it was frequented by the recuperating soldiers, earning it the nickname of 'The Wounded Tommy'.

For a large portion of the twentieth century the pub was simply known as 'Binnies' from the surname of the landlord, David McDonald Binnie. He had been born in Aberdeen in 1897 but by the early 1920s was working in the pub trade in Dundee and in 1926 he became licensee of the Taybridge Bar in Perth Road. In 1939, he took over the premises at Lochee High Street.

At the court session at which Binnie applied for the licence, Revd McIntosh Mowat, the city's champion of Sabbath observance, inadvertently caused much laughter when he revealed that he had once attended twenty-five pubs in Aberdeen in one night. When it came to Binnie's application, the police raised no objections and the chief constable remarked to more laughter in the court that the building was, in fact, owned by the Kirk Session of the Parish. The Kirk Session actually owned the whole block, including Soave's chip shop and Timlin's newsagents as well as Binnie's pub, but in 1952 sold it to the respective tenants. David Binnie died in 1954 but the pub stayed in the family for another decade.

In more recent years it was called Stacks Bar after Cox's Stack – the mill chimney that still dominates the local landscape long after the closure of the mill that gave it its name. Today it is known as The Last Tram. Dundee's tram service ceased in October 1956 when the last tram made its way into the Lochee depot, which was formerly situated immediately next to the pub.

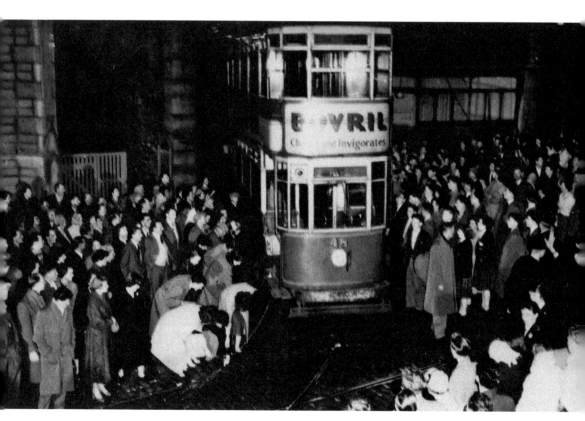

The last tram reaches Lochee in October 1956.

33. The Albert Bar, High Street, Lochee

The Albert Bar is Lochee's oldest public house. Originally known as the Albert Inn, it dates from the middle of the nineteenth century before Lochee was part of Dundee, and would have been a stopping place for travellers on the turnpike road to Coupar Angus. Behind the inn was a brewery as well as a malt barn, kiln and three-stalled stable. The brewery premises were entered by a narrow lane called Smalls Lane, which was later widened and renamed Sinclair Street. The lane took its original name from the family of the brewer Thomas Small.

The name of the inn itself was no doubt meant to honour Queen Victoria's consort Prince Albert, but locals tended to refer to it by its nickname of 'the brewers' even after production ceased there in 1874. The brewery premises were subsequently turned over to other purposes – first being leased to a manufacturer of jellies and later a maker of tobacco pipes.

In the 1870s, advertisements by the then proprietor of the Albert, Elizabeth Balfour, offered 'liquors of the finest quality' and drew particular attention to her bottling department: 'The ale and porter being of the finest quality and bottled under her own immediate superintendence.' Mrs. Balfour also showed herself to be well ahead of her time in the area of pub food. She offered 'dinners and suppers to order at the shortest notice'. 'Tripe suppers' – no doubt considered a treat at the time – were available on Thursday

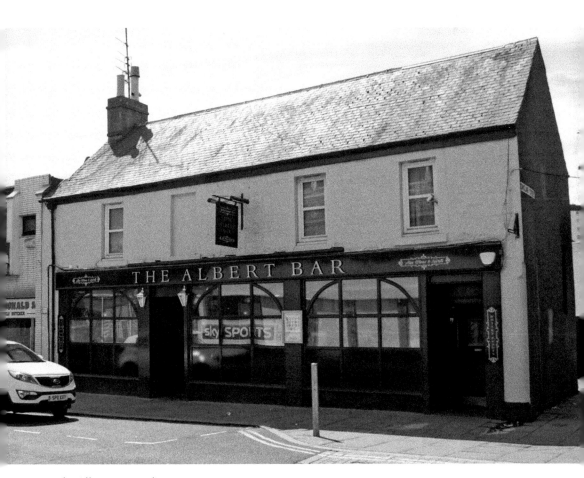

The Albert Bar, Lochee.

and Friday evenings. The adverts also pointed out the advantage of the inn's location 'two minutes' walk from the omnibus' and boasted that 'every attention would be paid to the comfort of visitors from a distance.'

By the twentieth century, when the brewery was a distant memory, it might have been thought that residents of Lochee would revert to using the pub's actual name and perhaps they did for a time. In 1947, however, the licence for the Albert Bar was granted to one Albert Bruce Kidd, thus earning the pub its latter-day nickname of 'Kiddies'. Sadly, Kidd died in 1950 at the age of forty-nine but his widow and family continued to run the pub for many years and the nickname is still commonly used.

While the pub and the surrounding area have been much altered over the years it is still possible to stand back and imagine how the Albert Inn would have appeared to travellers over a century and a half ago.

Hilltown and the North

The Hilltown or Bonnethill was once a separate barony outwith the boundary of Dundee. While still a well populated area, it is not as crowded as it was for much of the nineteenth and twentieth centuries. Among the pubs that have disappeared from this area in the last few decades are The Central Bar, which stood at the junction of Hilltown and Victoria Road, and the Windmill, which was at the corner of Ann Street. The Windmill was one of the oldest pubs in Dundee, but was in a much dilapidated state by the time it was demolished to make way for a housing development. Many people claim that the actor and comedian Robin Williams stayed in Ann Street before he was well known and visited the pub several times during appearances at the Edinburgh Festival in the 1970s. Another famous person who had an encounter with the Windmill was the Duke of Edinburgh. Passing the pub by car during the Queen's Silver Jubilee visit to Dundee in 1977, Prince Philip was seen to point at the Windmill. Following this, some of the regulars sent a letter to the duke in verse and were amazed to receive a poem in reply from him.

This chapter goes beyond the Hilltown itself and takes in several pubs between there and Clepington Road, before heading further north. Many of these are familiar to people from all over Dundee and, indeed, from other parts of Scotland in a way that they would not be were it not for the presence of both of Dundee's senior football grounds in the vicinity.

34. The Ladywell Tavern, Victoria Road

The Lady Well, which was situated at the foot of the Hilltown, just outside the old burgh boundary of Dundee, was once one of the principal sources of water for the town. The route to this well was known as the 'Well Gait' (later the Wellgate). In the early 1870s, the old well was removed to allow for the creation of Victoria Road. In its later years its reputation for purity had suffered. Indeed, in 1871, the *Dundee Advertiser* speculated that the Lady Well's water might be the worst in the country.

The Victoria Brewery was built on the site of the Lady Well in 1874 and the well's water was initially used for brewing the beer, though this had to be augmented with water from the city supply. In 1893, the brewer John Neave had a new artesian well some 200 feet deep sunk at the brewery and the water produced was said to be of 'perfect purity'.

Beer was sold initially from the brewery's shop under a 'porter and ale' licence. In 1903 Neave successfully applied for a full public house licence for the premises at No. 16 Victoria Road. This was part of the brewery that consisted of the ground floor of a two-storey building to the left of

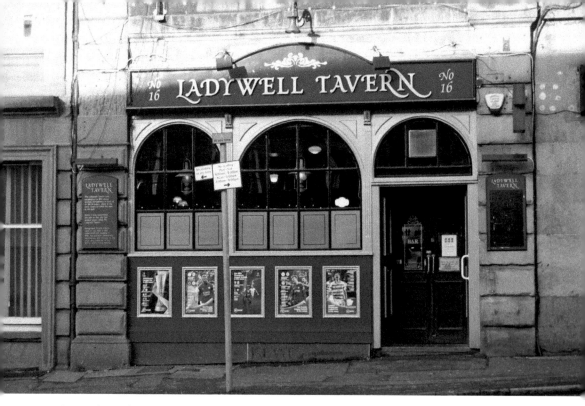

Above: The Ladywell Tavern.

Below: The Victoria Brewery entrance and site of the Ladywell Tavern.

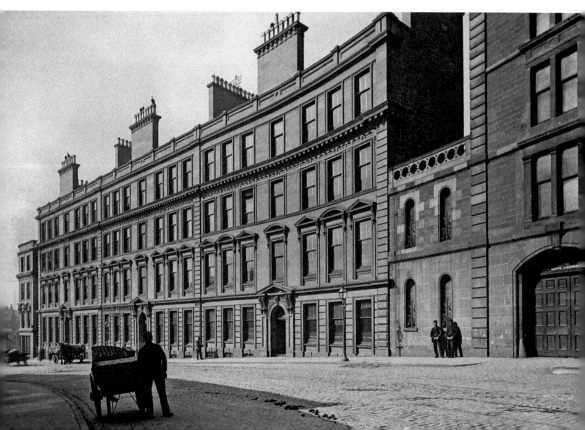

the main entrance archway. This is the Ladywell Tavern as it is known today. Additional floors have been added above the pub and the archway site is now a shopfront.

In 1910 the firm of John Neave and Sons Limited went into liquidation and the entire brewery premises were sold but the public house licence was transferred into Neave's own name. He died in 1911 and the Ladywell Tavern was taken over by his son, who went on to buy the pub in 1914. The remainder of the brewery was converted to retail and residential use and for many years was owned by McGill Brothers Ltd.

Alfred Neave died in 1931 and the Ladywell Tavern was sold to Thomas Scott. Whatever changes the new owner made, according to a sign outside the pub today, he did not alter its name – and nor did any subsequent owner or licensee. Few of Dundee's historic pubs have not – even temporarily – changed their name. Other changes were certainly made over the years, but in 1998 the Ladywell Tavern was extensively refurbished to return it to its original character.

35. The St Andrew's Tavern, Rose Street (demolished)

The St Andrew's Tavern in Rose Street was a seemingly insignificant backstreet pub, but was famous in Dundee for two reasons. One was that it was reputed to be the city's smallest drinking establishment, while the other was its curious nickname – 'The Mad Dog' (or 'Doag' in the Dundee vernacular). This name was said to have come about because a former landlord had been bitten by a dog while cleaning the pub's windows. Some have disputed this, however, suggesting that it came from a sign that used to hang outside the pub depicting a St Bernard dog and advertising the wares of the Edinburgh brewers T&J Bernard.

At first sight, the latter is the more likely explanation. Why would an incident as trivial as someone being bitten by a dog be remembered and considered significant enough to nickname

St Andrew's Tavern – The 'Mad Dog'.

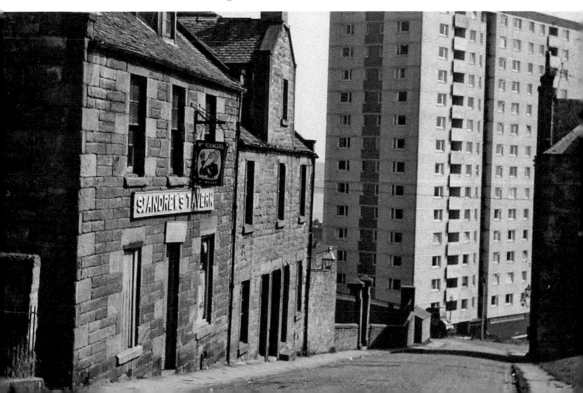

a pub? Indeed, 'dog bites man' is traditional journalistic shorthand for a non-story – the story worth publishing, of course, being 'man bites dog'.

To uncover the real story, we have to travel back to the early days of January 1870, around a century before the pub's eventual demolition. At this time, the landlord was a man in his early fifties named James Crighton. Crighton had been a mill overseer for many years before becoming a publican, although he was said to be 'almost a teetotaler' himself. Whether he was actually washing the windows or not when it happened is not clear, but James Crighton was certainly bitten by a dog. The animal, described as a 'brown retriever' had sunk its teeth into the palm of his right hand.

The wound slowly healed, though, and Crighton felt no lasting ill effects until Sunday 30 January when he began to feel unwell. His condition rapidly worsened and he made his way to the infirmary. The doctors there immediately suspected 'hydrophobia' – or rabies as it is better known today. Such was the treatment meted out at that time for the agitation caused by the illness that the poor man was confined to a straitjacket. By the Monday night he was unconscious and he died at midnight on Tuesday.

It was undoubtedly this tragic event that earned the St Andrew's Tavern its nickname, though the passage of time meant that the details of the story were lost, other than a vague recollection about a landlord having been bitten by a dog.

36. Harlequins, Albert Street

In the nineteenth century the pub at the corner of Albert Street and Arbroath Road was called the Baxter Park Bar after the nearby park of the same name. The park, in turn, took its name from Sir David Baxter who donated it to the city. The pub name was later shortened to the Park Bar, and it retained this for much of the twentieth century.

Harlequins.

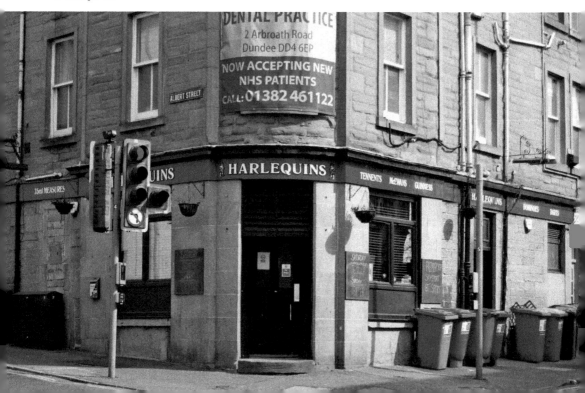

It was given a quite dramatic name change, however, when a well-known local sporting figure took over. Paul Sturrock made more than 500 appearances for Dundee United and was part of the team that won the league title in 1982–83. Sturrock had been given the nickname 'Luggy' – denoting prominent ears – in his earliest days as a youth player with the club. He embraced the name with good humour and has been known by it ever since. It seemed only natural that he would rename the pub Luggy's. During his tenure, the exterior was painted in the Dundee United colours of tangerine and black.

The Luggy's name was never likely to outlast Paul Sturrock's time in charge, though, and after his departure the pub reverted to being the Park Bar before becoming the Cask. It is now known as Harlequins. Meanwhile, the premises at Nos 173–177 Princes Street, which had previously been Harlequins reverted to its earlier name of the North Eastern Bar. After refurbishment in 2019, that pub, in turn, adopted the name the Smugglers, which had previously been the name of a pub in Constable Street. There will no doubt be many conversations held at cross purposes in future years when people try to recall the locations of these pubs.

37. The Ellenbank Bar, Alexander Street

The Ellenbank Bar is perhaps most known for two things: a famous landlord and a famous visitor. The landlord was one of Dundee's greatest sporting heroes, while the visitor was the man that many consider to be the greatest boxer ever.

The landlord, George Kidd, was a superstar of the professional wrestling world. After taking the Scottish lightweight title in 1947, he went on to secure the British then the European title. In 1949, he defeated the man generally recognized as the reigning world champion – Rudy Quarez of Mexico. Some disagreed, though, and refused to recognise Kidd's title, preferring the claim of

The Ellenbank Bar.

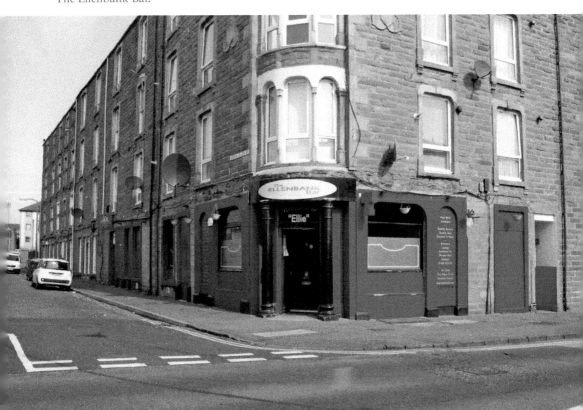

the Frenchman Rene Ben Chemoul. Kidd could have simply held a rival title, but he wanted to be the undisputed champion, so he duly defeated Chemoul as well.

George Kidd took his wrestling seriously and studied the sport and its various manoeuvres and holds as well as investigating other means of self-defence and fitness. Where other fighters simply concentrated on building bulky muscles, Kidd practised yoga to keep his muscles supple and his mind sharp; where others adopted outlandish gimmicks and nicknames, he concentrated on his wrestling. When wrestling became a major television phenomenon, Kidd did not appear as often as some of his fellow professionals, fearing the impact that over exposure would have on the sport. By the 1960s, though, he was well aware of the impact of television, having become a well-known personality in the Grampian TV region as presenter of *Wednesday People* and *The George Kidd Show*. Kidd retired from wrestling in 1976, still the undisputed and undefeated world lightweight wrestling champion. He died in 1998.

The Ellenbank's most famous visitor appeared there at the behest of George Kidd in September 1964 when he was introduced to several luminaries of Dundee's boxing scene. Sugar Ray Robinson had held the world welterweight title from 1946 to 1951 before going on to hold the middleweight title. His professional record at his retirement in 1952 included 128 victories (eighty-four of them knockouts) including a ninety-one-fight unbeaten streak. Robinson's extravagant lifestyle and the relative failure of his attempts to establish an alternative career saw him back in the ring by 1955. The visit to Dundee came at a time when he was in his forties and long past his best as a fighter. Nonetheless, it is still remarkable to think that one of the world's greatest ever sportsmen visited a Dundee pub.

38. The Snug, Church Street

There has been a pub at the corner of Main Street and Church Street since 1876, when the first licence was granted to Jonas Kidd, who previously had a business in the Murraygate. Sometimes

The Snug.

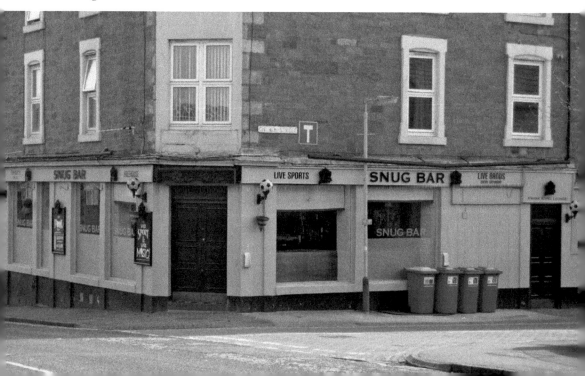

it is not possible to determine how long a pub has had a particular name as records such as licence applications and advertisements tend to simply list the street address and the name of the landlord. An advertisement that appeared in the local press in 1891, however, referred to the pub at Nos 75 and 77 North Church Street as 'The Snug', meaning that the name dates back more than 120 years.

It was not just the pub that had the name. The 1891 advert was actually for a whisky called 'Snug' that was only available at the pub. It reproduced a letter from Granville H. Sharpe FCS, late principal of the Liverpool College of Chemistry who had analysed the whisky and was satisfied as to its 'great purity of composition and highly matured state'. Mr Sharpe must have made a good living as an analyst as his name appears on several such recommendations in this period.

The Snug is older than both of Dundee's senior football teams so it must have been a great boost to the pub's custom, when they became established in the area. It remains popular with football fans to this day so it is appropriate that the lounge now bears the name of a Dundee United great. Born in Falkirk, left back Frank Kopel was signed for Manchester United by Matt Busby as a teenager. Transferred to Dundee United from Blackburn Rovers in 1972, he remained at the club for ten years and won the League Cup twice during that time, as well as reaching two Scottish Cup finals. Perhaps his most famous moment was the equaliser he scored against Anderlecht in the UEFA Cup in 1979, which took United through to the next round.

In 2008, Frank was diagnosed with dementia. As he was not yet sixty-five, he did not qualify for free personal care. This sparked an ultimately successful campaign to change the law led by Frank's wife Amanda. 'Frank's Law' – which extended free care to under sixty-fives – came

The Snug at Church Street – the Frank Kopel Lounge.

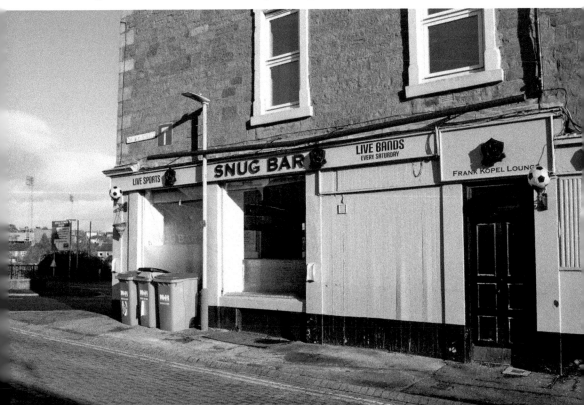

into effect in 2019. Sadly, Frank Kopel died in 2014, but the Frank Kopel Lounge, the Dundee United supporters' club, Frank Kopel's Travelling Shindig (which is based at The Snug) and, most importantly, Frank's Law, help to keep his name alive.

39. The Barrels

A first glance, it would appear that The Barrels, a combination of a pub and a large restaurant area, with its modern frontage and furnishings has a much shorter history than its near neighbours The Athletic Bar and Frew's, but this is not case. There has been a public house at No. 45 Strathmartine Road, albeit much smaller than the present premises, since the late 1860s. The name, in its earlier form as The Three Barrels, also dates back to the nineteenth century.

Many people will recall the Three Barrels during the period that Jeff Stewart was the landlord. Despite having no family background in the licensed trade he made a great success of the pub, at one point serving 14,000 pints a week and earning it the reputation as the busiest bar in Scotland. Such was its fame and popularity at the time that the advertisements in the local press simply depicted a drawing of three barrels with the slogan, 'Need we say more?' Even a potentially devastating fire in 1989 was turned into a triumph, when the pub was speedily reopened. He went on to further success with other premises including the Occidental, the Ship Inn and the Hotel, Broughty Ferry.

Jeff Stewart is by no means the only member of his family to have made a success of the pub business. His brother Jonathan took over the Ladywell Tavern in 1974 and became a pioneer of real ale in the city. He too went on to other bars including the Shakespeare, McGonagall's, Mennie's, the Fisherman's Tavern and the Royal Arch.

The Barrels: need we say more?

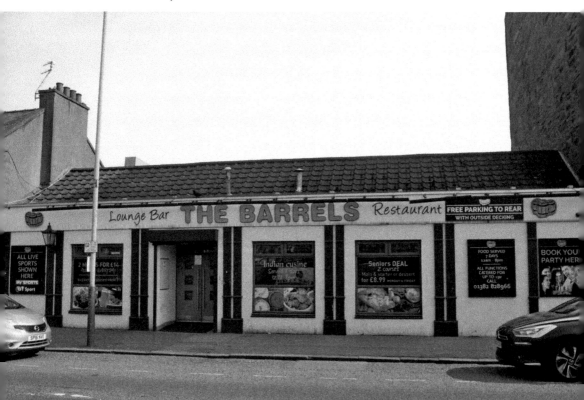

40. The Athletic Bar, Strathmartine Road

In 1901 local residents led by the chairman of the School Board and the minister of United Free High Church strongly objected to a licence for a new public house at No. 93 Strathmartine Road. The area's councillor Bailie Charles Barrie, future Lord Provost and the man who donated the Hilltown Clock to the ward said that the vicinity was already 'a little hell' on Saturday night and he did not know what it would be like with an additional public house. The licence was refused.

This decision was reversed in 1907, however, and the Athletic Bar opened on the premises that year. The reason for this reluctant change of heart on the part of the licencing authorities is to be found in Bell Street where the Technical Institute (the forerunner of Abertay University) had purchased premises to build a new college. These premises included a public house whose lease still had four years to run. The college could not be built until the pub was vacated. The publican, Robert Brand, secured the transfer of the licence to Strathmartine Road and even got the Technical Institute Committee to pay for the refitting of the shop there.

The Athletic Bar was generally known as 'Hungry Boab's' after Robert Brand. The epithet 'hungry' implying a less than generous nature was often applied to pub landlords in this period. Brand ran the pub for forty-seven years until his death at the age of eighty-five, by which time he was, unsurprisingly, the oldest active member of the licenced trade in the city. The pub's nickname long outlasted Brand's tenure but the official name remained the Athletic Bar, though, and became, perhaps, more appropriate when the pub came into the ownership of one of the Dundee's most famous sportsmen in 1974. Doug Smith, a native of Aberdeen, was undoubtedly one of Dundee United FC's greatest ever servants. He signed for the club in 1957 and made his

The Athletic Bar – 'Hungry Boab's'.

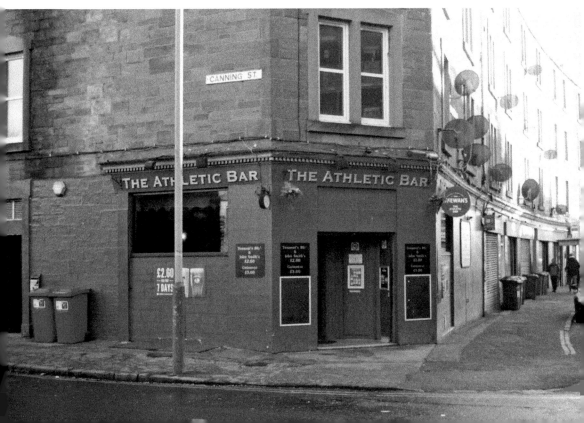

first team debut two years later. In all, he spent the seventeen years as a player and, eventually, club captain, playing a total of 628 games without ever being booked or sent off. He was later a director, vice chairman and chairman of the club. He was a popular host at the Athletic, a favourite pre-match venue. He died in 2012.

41. Frew's, Strathmartine Road

In the early years of the twentieth century, the shop at the corner of Strathmartine Road and Moncur Crescent was a licensed grocer's run by John Guthrie Bowman. Bowman ceased trading shortly after the outbreak of the First World War and later emigrated to the United States. In 1915, the premises were taken over by William Stewart who ran a pub in the High Street known as The Plough. Stewart transferred the licence and the pub name to Strathmartine Road. The name was retained for many years and a plough motif is still visible on the stained-glass windows. In 1982, The Plough was taken over by William Frew, who ran the popular Frew's Bar in Hawkhill and he too brought the name of his previous pub with him (as well as many faithful customers).

The large public bar remains largely unaltered since 1915, though there was once a small snug to the right of the bar. Original features include the wood panelling, cornices and back gantry with bevelled mirror panels. There is also a large inglenook fireplace. There are carved details on this showing crossed pipes in between two tobacco jars. When one of these was removed it was found to be inscribed on the back: 'H & F Thomson Architect. Alex Fair Wood Carver. John Scott Joiner. Mr Stewart Licence Holder. 18th October 1915'. The architects Henry and Frank Thomson were sons of the City Engineer James Thomson.

Frew's Bar.

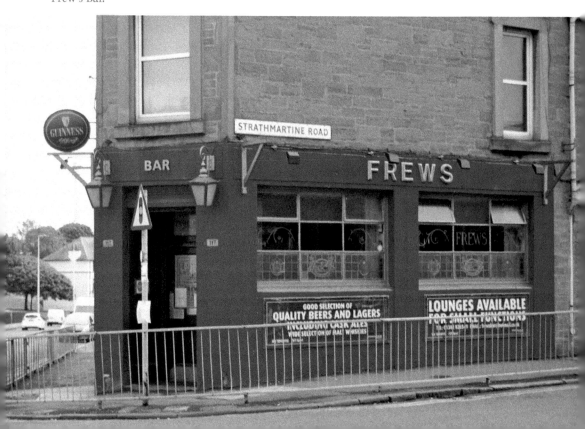

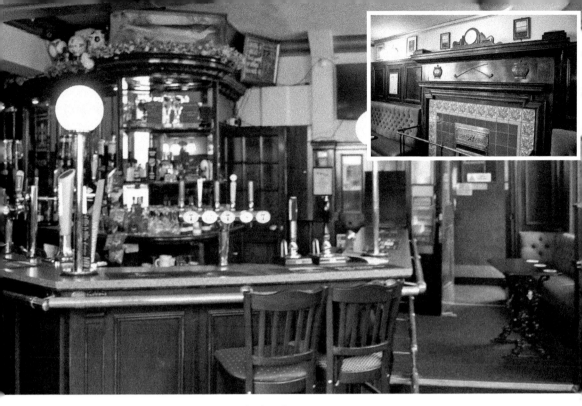

Above: The main bar in Frews. *Inset*: the fireplace.

Below: The lounge on the Strathmartine Road side.

Above: The art deco sporting-themed lounge.

Below: The bar and gantry in the lounge.

There are two further lounges dating from the interwar period. The one on the Strathmartine Road side has its original wood panelled walls and fireplace. Among the pictures that adorn the walls is one of the old Frew's Bar on Hawkhill. The second lounge on the Moncur Crescent side is outstanding in retaining many of its original art deco features, including the panelled walls, bar counter and gantry, fireplace, fixed seating and tables. It is said to be a replica of a bar on Ocean liner the *Queen Mary*, which certainly dates from the same period. Today this room has been given a sporting theme and is decorated with pictures and memorabilia, which is appropriate given the proximity to Dundee's two senior football grounds, though the theme is not limited to football.

Willie Frew retired in 1998 and died in 2020 at the age of ninety-two. The business was taken over by his daughter Janette and son-in-law Jim Kidd, who continue to run it today.

42. The Ambassador, Clepington Road

Billiards and its younger relation, snooker, were extremely popular in the Dundee of the early 1930s. Among the billiards saloons in the city were the Albert Square Billiards Parlour, the Imperial Billiard Saloon in the High Street, the Arthurstone Terrace Billiards Saloon and the North End Billiards Saloon in Stirling Street. Theatres and cinemas such as the Caird Hall, the Kinnaird in Bank Street and the La Scala in the Murraygate also had their own tables.

The Ambassador.

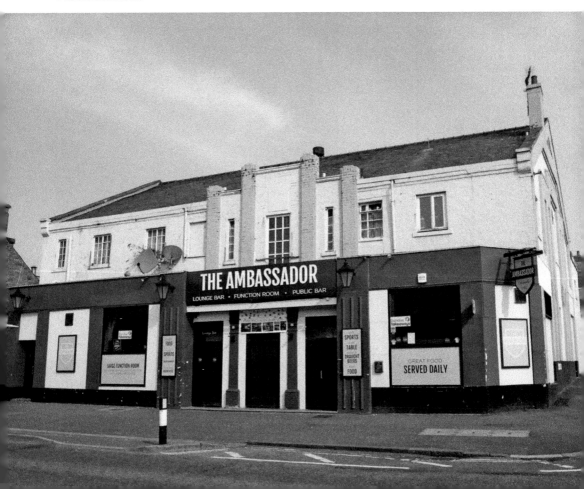

On 20 October 1932, a new billiards facility opened at Clepington Road. The Clepington Billiard Saloon boasted the most up to date rooms in the city including twelve first-class tables. There was a ladies' private saloon, which had two tables and an exhibition room that had seating for more than a hundred people. In a forward-thinking move for the early 1930s, proprietor Andrew Lamont had also provided ample car parking.

The Clepington Billiard Saloon proved extremely popular. As well as staging billiards and snooker tournaments, it also played host to table tennis competitions, dances and functions. During the Second World War, the Fairways Dance Club, which met there every Saturday night, mentioned in its advertisements that gas masks were available on the premises for dancers.

Over the years, snooker overtook billiards as the most popular cue sport but by the mid-1960s, its popularity too had begun to decline. (It would be boosted later that decade when television coverage began and would gain new heights of popularity in the 1980s.) The Clepington Billiard Saloon was sold in 1966 and became the Glen Lyon Bar and Restaurant. It later became The Ambassador and then the Centenary Bar. Today it has reverted to The Ambassador name and still caters for functions, though, thankfully, gas masks are no longer required.

43. The Clep, Clepington Road

In 1936, the council's housing committee decided to purchase the property at Nos 104–06 Blackness Road at a cost of £725 in order to build new houses on the site. This created a problem for Thomas Fitzpatrick, the landlord at the public house there. Fitzpatrick tried to get a licence

The tiled frontage of The Clep.

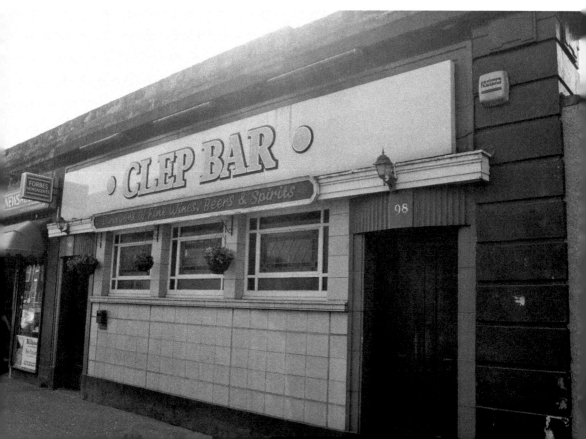

Above: Inside The Clep.

Below: Another view of The Clep looking towards the bar.

Above: The Clep's lounge.

Below: The stained glass in this view shows the location of the lounge.

for the shop at No. 88 Dens Road but this was turned down. He then applied to build a new pub on the Kingsway near its junction with Forfar Road, but this was also rejected. Finally, in 1940, he applied for a licence for two shops in a block at Clepington Road, which had been built in the late 1920s. The shops were at the time occupied as a baker's and a fishmonger's.

This move was not without its controversy. Many were reluctant to see the spread of pubs to the housing schemes and the new pub was close to the Fleming Gardens estate, which was erected as a result of a gift of £155,000 from banker Robert Fleming (grandfather of James Bond novelist Ian Fleming). Nevertheless, the move was approved and the Clep Bar opened in 1941. The name, of course, is an abbreviated version of 'Clepington'. Clepington Road was once the main access to the estates of Easter and Wester Clepington, once the property of the Clephane family and originally known as 'Clephane-toun'.

The exterior of the Clep, with its tiled façade and leaded windows (the central one advertising Bernard's Edinburgh Ales), remains largely unchanged from its early days, though a modern sign has replaced the original raised lettering in recent years.

The interior too is remarkably well preserved. The three sections of the pub – the public bar, lounge, and jug and bottle or off-sales counter – are all as they originally would have been. There are three-quarter-height wood-panelled walls throughout, which are adorned with pictures and memorabilia relating to both Dundee football clubs, as well as other sporting heroes.

Original features include the bar counter and gantry as well as the bench seating with its wooden dividers, the fixed tables and the tiled fireplace. There is also a pre-decimal till and working service bells set into the walls. The credit for the survival of the Clep's original interior is surely due to the long period of ownership by the Fitzpatrick family, which did not end until 1990 – the year The Clep became a Category B listed building.

44. The Downfield (Doc Stewart's), Strathmartine Road

In the early 1830s, as the Dundee and Newtyle railway spread outwards, a station was built to serve the village of Baldovan. The new railway line had the effect of isolating a large triangular piece of ground between itself and the road to Baldovan near the station. This, in turn, inspired a man named John Wishart to purchase this ground in 1835 and lay out plans for a village. The writer J. M. Beatts described how various names were considered, including 'Wishartfield' and others to reflect Wishart's occupation as a feather merchant – 'Featherfield' and ultimately 'Downfield'. Some have dismissed this story as a myth, but official documents do describe Wishart's occupation as 'feather merchant' and there seems to be little reason to doubt it.

Wishart had the foresight to include a tavern in his plans and The Downfield Tavern (later the Downfield Hotel) has been serving the local area ever since. The premises have been much altered and expanded since the early days and Downfield village has long since been swallowed up by Dundee. One thing, though, has not changed in more than a century and that is the pub's nickname – 'Doc Stewart's' or simply 'Doc's'. Who, though, was Doc Stewart?

James Stewart was born in Glamis in 1860, the son of a shepherd. His mother died when he was only nine years old. When he was thirteen he moved to Dundee and served his apprenticeship with William Low & Co. before setting up business as a licensed grocer in the Hilltown. In 1893, Stewart married Jessie Warner whose family had been the licensees of the Downfield Tavern since 1871. Jessie herself had been in charge since her mother's death in 1890.

Jessie died in the flu epidemic of 1918 and 'Doc' Stewart continued to run the Downfield until his death in 1935 at the age of seventy-five. A keen bowler and curler in his younger days, he was said to have a genial personality, which endeared him to people.

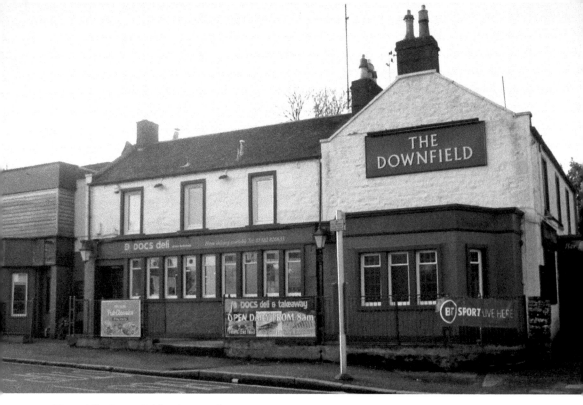

Above: The Downfield, otherwise known as Doc Stewart's.

Below: The Downfield today is much expanded from the original building.

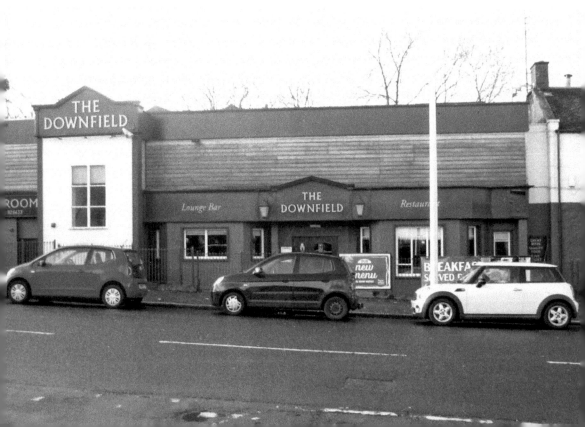

How, though, did the nickname Doc come about? One theory is that in the days when visiting a public house was not as acceptable as it is now, and was considered something to be looked down upon, children would be told that their father had gone to the doctor's or the chemist's or some other such euphemism. It seems that Doctor Stewart had so many 'patients' that the name stuck.

45. The Nine Maidens, Laird Street

As Dundee began to spread outward in the years after the Second World War, the demand for pubs in the various housing schemes increased, but the council was reluctant to grant licences for them, fearing the impact on local communities, much to the frustration of some residents. In 1954 a correspondent calling himself 'Not Quite T.T' wrote to the *Courier* saying, 'It has always been an ostrich position – refusing licences in the outskirts. It just means that the man who likes a refreshment has to spend extra money on a long bus trip into the centre of the city. And once he's got there, he usually partakes of more than he would do, at much greater cost, [than]if he had been able to walk along to his "local" in the evening.'

By the 1960s, the council had eventually seen the logic of such arguments and scheme pubs had become commonplace. Such pubs have become important focal points for their communities, but their purely functional buildings and relative lack of history means that they do not feature much in this book. One exception is the Nine Maidens in Laird Street, which appears because of the myth associated with its name, which is older than any pub in the city.

The story concerns a farmer at Pitempton who had nine daughters, one of whom was sent to fetch water from a local well. When she did not return, another daughter was sent. She, too, failed to return and another was sent, and so on until all were missing. Finally, the farmer himself went to the well where he found a dragon or serpent resting after devouring his beautiful daughters. He ran off and gathered his neighbours to kill the creature. Chief among them was Martin the blacksmith, who had been betrothed to one of the nine maidens.

The dragon was driven to Strathmartine where the people urged Martin calling out 'Strike, Martin!' – supposedly giving the area its name. He did, but it staggered on and died at Balkello Farm where a Pictish sculptured stone depicting the creature stands to this day.

The events of the myth are commemorated in a statue of the dragon in the city centre and also in the name of Baldragon Academy, but it is perhaps the Nine Maidens pub that provides the most apt memorial. Each of the nine maidens, after all, had set out to fetch a drink.

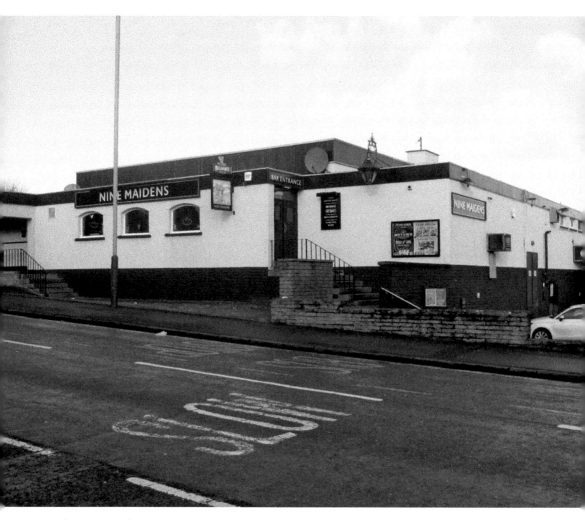

The Nine Maidens.

5

Broughty Ferry

Broughty Ferry has gone through many changes since its origins as a small fishing village nestled in the shadow of the fifteenth-century castle. The industrial age saw wealthy industrialists arrive and build their grand residences, while the coming of the train saw the town become a popular destination for holidaymakers. In 1913, Broughty Ferry officially became part of Dundee.

'The Ferry' has long had a number of pubs that appeal to both residents and visitors alike. One weekend in January 1883, an unofficial census was taken at Broughty Ferry's ten churches and eleven public houses. The survey found that 2,733 people attended church, with 1,524 going to the pub. Allowing for the number of children attending church, it was estimated that numbers were roughly equal (though no numbers were available as to how many had attended both!).

Broughty Ferry still has several pubs (and, indeed, churches). The number of pubs varies depending whether or not some outlets with an emphasis on food or hotels are included but there are more than enough for a decent pub crawl. Reasons of space mean that we cannot make extended visits to them all in this chapter but we can pop in briefly to a few others:

The Occidental Bar's name means western – the opposite of 'oriental'. It may seem strange that a pub in one of the most eastern parts of Dundee should have this name, but, of course, the Occidental is on the western side of Broughty Ferry and long predates it being part of Dundee. The Post Office Bar was, as its name suggests, once a post office and dates from 1907. Sol y Sombra in Gray Street was previously the Lorne Bar and the Ferry Inn. In between both of those names when the landlord was the legendary Dundee FC player Bobby Cox, it was called the Sliding Tackle. Jolly's Hotel is also in Gray Street and takes its name from John Jolly, who was its proprietor in the 1850s and 1860s. In April 2014 a renovated version of Jolly's much expanded from the original building was opened by JD Wetherspoon.

46. The Gunners, King Street
The Gunners owes its name to the artillerymen who were once stationed at Broughty Castle, and indeed to one gunner in particular. Neil Lorimer Outram Smith was born in Portsoy, Banffshire,

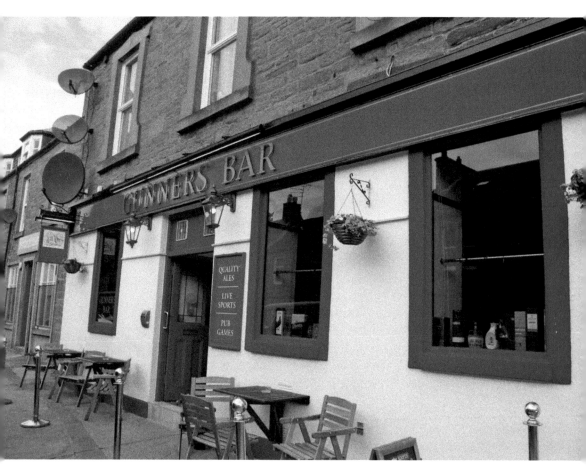

The Gunners Bar, Broughty Ferry.

in 1873, the son of a salmon fisherman. He joined the Royal Artillery at Aberdeen in 1894. Smith saw five years' service in Egypt during the British occupation there and was promoted to the rank of corporal in 1897 and sergeant in 1902. He completed a master gunner's course four years later and was subsequently appointed master gunner of the Broughty Castle, Buddon and Aberdeen Coast defences, with his headquarters based in Broughty Ferry. Master Gunner Smith became a well-known figure in Broughty Ferry and the surrounding district. During the period of the First World War he organised concerts in Dundee's parks in aid of military charities and the Red Cross.

Smith retired from the army in 1920. His army records describe him as steady, hardworking, reliable and intelligent and of exemplary character. In his younger days, he had been a fine athlete and runner but by the time of his retiral, his medical records describe him as 'a very obese man' and note that he suffered from sciatica. Despite this, in 1922, Smith embarked on a new enterprise taking over a public house in King Street, Broughty Ferry. The pub in question had opened in 1871 and was known as the Freemasons Arms. It became known as The Gunners under Smith's ownership and it has retained that name ever since.

47. The Eagle Coaching Inn, King Street

The Eagle Coaching Inn is reputed to be Broughty Ferry's oldest pub. Architectural guides date the oldest part of the current building to the late eighteenth century, but a sign on the outside of the premises tells of a longer history. It describes how old coins discovered during renovations in the 1950s indicated that it dated back to at least 1636.

The 'coaching' part of the pub's name dates from 1826 when a coach service began operating between Broughty Ferry and Dundee, leaving from and returning to the Eagle. Initially running four times a day, the service carried the post and such passengers as could afford to travel in what was described at the time as a 'rumbling and capricious vehicle'.

Before the coming of the railway, most ordinary Dundonians would make their way to Broughty Ferry by steamer or on foot. The Eagle's clientele in this period, though, were an altogether wealthier group, who had their own means of transport. In 1897, an *Evening Telegraph* article painted a picture of the Eagle half a century or so previously: 'Sunday was the busiest day in Broughty Ferry. At the Eagle Inn yard may have been seen as many as 30 vehicles, principally two-wheeled gig, in which business men had driven from Dundee to Broughty Ferry to dine in the Inn.'

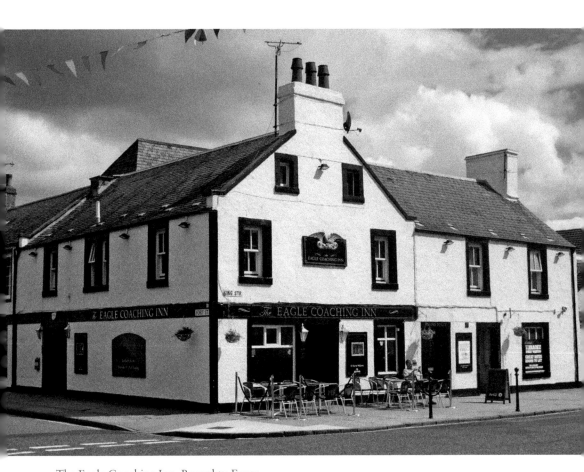

The Eagle Coaching Inn, Broughty Ferry.

The carved eagle emblem dates from the 1860s.

A striking feature of the building to this day is the magnificent carved eagle that adorns the front of the pub. It dates from the 1860s and is the work of James Law, who was famous for creating ship's figureheads. The building was expanded in the mid-nineteenth century to add the wing to the east and around this time, it began to be listed as the Eagle Hotel. It has since been expanded on the Fort Street side as well.

As might be imagined, there have been many proprietors over the years. Among them was Jane Easton or Gibson, who in 1858 opened the Eagle as a temperance coffee house, which would perhaps be more impressive if she had not done so only after twice failing to get a licence to sell alcohol. Another was Bert Thomson who later became landlord of Thomson's Bar in Bell Street. There was also William Low, who was a well-known swimmer as well as being the Eagle's landlord. In 1910, he rescued a boy from drowning and also set a record for swimming the Tay (presumably on different occasions).

48. Fisherman's Tavern, Fort Street

A much-favoured Broughty Ferry pub, the Fisherman's Tavern reputedly began life in a single terraced house in Fort Street almost 200 years ago. The house, as the name suggests, was home to a fisherman but in its early days the pub was known as the Buckie Tavern. 'Buckie' is another word for a whelk, the shellfish that has long been harvested and consumed on the shores of the Tay. Both names point back to Broughty Ferry's origins as a small fishing settlement in the shadow of Broughty Castle.

Over the years, the Fisherman's Tavern has expanded to take up several of the houses in the terrace of houses in Fort Street, of which it forms part and it now includes a dining area, beer garden and hotel accommodation. The gradual expansion and a major refurbishment in 2018 have caused some to fear that the pub's unique atmosphere might be lost but the confines of the early nineteenth-century building and the setting near the river's edge meant that this was always unlikely and it has proved not to be the case.

'The Fish' has the distinction of being the only Scottish pub to feature in every edition of the *Campaign for Real Ale's Good Beer Guide* since it launched in 1974. By the time that organisation was founded in 1971, many pubs had changed to more convenient but highly processed and carbonated keg beers. The Fisherman's Tavern, however, had been in the Brodie

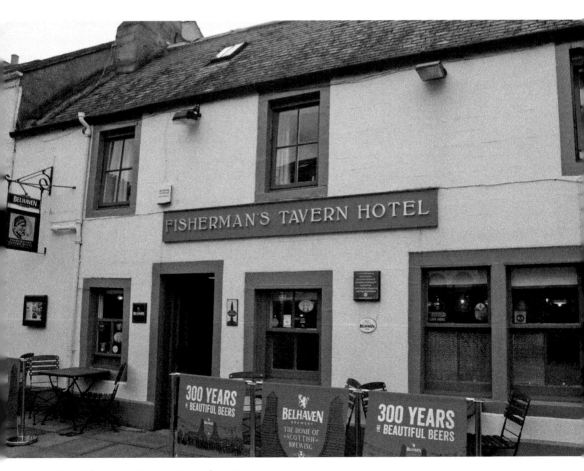

The Fisherman's Tavern, Broughty Ferry.

family since 1932 and Dick Brodie, who took over the licence in 1948, had continued with the traditional cask-conditioned ales that his father Robert had sold.

49. The Ship Inn, Fisher Street

As the name and address might suggest, the Ship Inn is situated at the water's edge looking out to the River Tay. The pub's website states that it was established in 1847, but even this might be an underestimate. In 1901 when Walter Taylor applied to take over the licence, his solicitor said that the premises had been licenced for almost 100 years. Among Taylor's successors was Alexander Grant who took over in 1932. Grant, and later his wife, ran the pub until 1959, during which time the pub was often referred to as Sandy Grant's.

Today the Ship Inn is much expanded from what it would have been in Grant's day. At its heart is still a cosy nautical-themed pub with its distinctive bar featuring two ship figureheads,

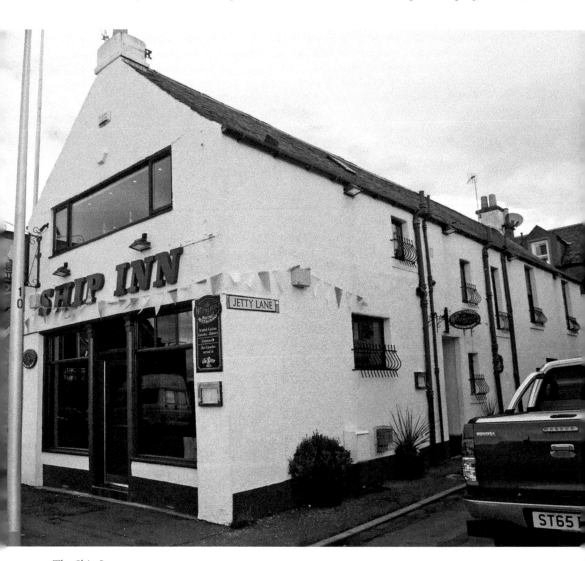

The Ship Inn.

but it also includes an upstairs restaurant with views to the river as well as a holiday cottage and apartment. In addition, the Ship Inn provides a much more unusual service. For the payment of a deposit, the bar staff will lend you a key to a graveyard. Not far from the Ship Inn is the site of a pre-Reformation chapel from which both Church Street and Chapel Lane take their names. Long after the old chapel had gone, the burial ground associated with it continued to serve the fishermen and their families as well as the wider Broughty Ferry community. It was officially closed in 1867 though unofficial burial continued for a time. In more recent years, Broughty Ferry Development Trust oversaw the installation of new gates and information boards that explain the story of this little known but fascinating aspect of Broughty Ferry history and the many interesting old gravestones it contains.

50. The Royal Arch, Brook Street
The pub that today comprises the Royal Arch began life in the mid-nineteenth century as the Railway Tavern. An official survey from the late 1850s when it was run by a Mrs Mary Miller, describes it as 'a small Inn, one storey high, licenced to sell malt liquors, and spirits'. By the

The Royal Arch from Gray Street.

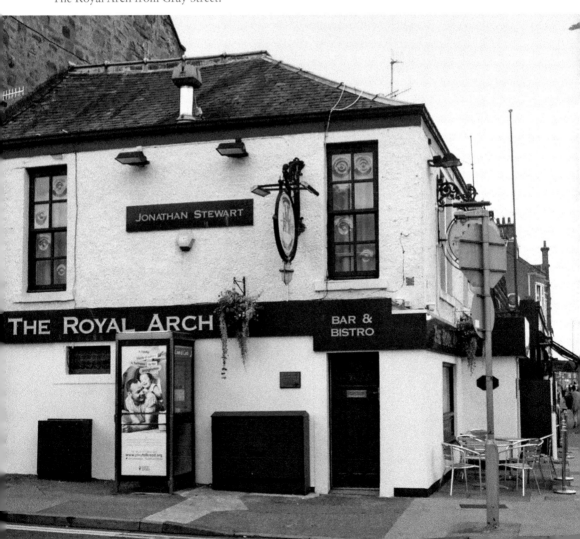

late 1860s, it was known as the Royal Arch Hotel, which suggests that the main part of the building we know today dates from this time.

There is some debate as to where the Royal Arch name came from. The most obvious explanation is that it was named after the decorative stone arch that was built at Dundee's docks to commemorate the visit of Queen Victoria in 1844. Some of the pub's features, such as its sign and one of its stained-glass windows, certainly point to this being the case. It has also been suggested, however, that the name, in fact, comes from the Royal Arch Chapter of Freemasonry, as the Broughty Castle Lodge was for many years located opposite the pub.

At first glance, the Masonic Lodge argument seems to make more sense on the basis of geography alone. There was once a Royal Arch Tavern at Shore Terrace in Dundee near the arch itself but why would a pub in Broughty Ferry be named after an architectural feature in what was then a separate town?

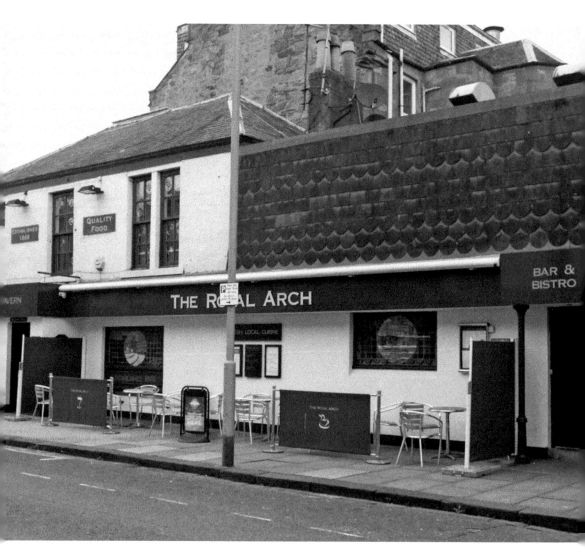

A view of the Royal Arch from Brook Street.

There is, however, a possible explanation. In March 1863, the Prince of Wales (later Edward VII) married Princess Alexandra of Denmark. There were celebrations of this wedding throughout the country. A report in the *Advertiser*, tells of a structure that was built at Broughty Ferry:

> A magnificent arch, consisting, in fact of eight arches, has been erected at the crossing of Brook Street and Gray street. The grand crown will be placed on top, and at night both arches and crown will be brilliantly illuminated. The height, to the top of the crown, is forty-three feet; the breadth of the Royal Arch, thirty feet; and the breadth of the side arches, ten feet each.

The arch was removed a fortnight after the wedding. Some hoped that a more permanent iron structure might be put in place but this did not happen. It seems likely that the pub adopted its name in commemoration of Broughty Ferry's temporary Royal Arch.

Acknowledgements

Thanks to Zoe Cooper, David Evans and Debbie Paton, Hugh Gray, Nat Hampton, John Justice, Jim Kidd, Dimi Savvaidis, Jonathan Stewart and Mark Usher.

All of the older photographs are from my own collection apart from the ones on pages 15, 17, 20, 44 and 68, which are courtesy of Libraries, Leisure & Culture Dundee. Thanks to Erin Farley for assistance with these. The modern photographs are all taken by me except for the ones on page 37. Thanks to Dimi for these.